IMAGES
of America

SAN FRANCISCO ZOO

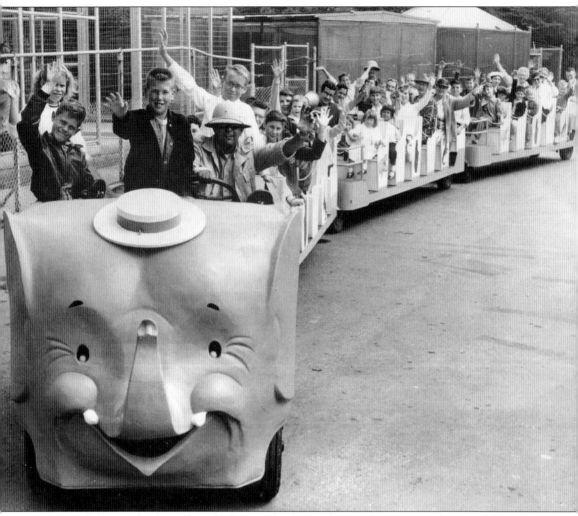

Pictured above is the first of four elephant trains designed by local artist Don Clever and ordered by the zoo's train concessionaire, Jack Kenny. Daily tours on the train cost zoo-goers 30¢ for adults and 15¢ for children. (Courtesy of the San Francisco History Center, San Francisco Public Library.)

ON THE COVER: The Little Puffer miniature steam train was built in 1904 and installed at the new Herbert Fleishhacker Zoo in 1925, where it currently remains. In 1935, newspapers claimed Little Puffer was the only train in San Francisco to make daily round-trips with 42 passenger loads—full capacity. This took place in the train's three cars around the .3-mile track in three minutes. (Courtesy of the San Francisco Zoo.)

IMAGES

of America

SAN FRANCISCO ZOO

Go wild, cats!

Katherine Girlich

Katherine Girlich

class of 2011

ARCADIA
PUBLISHING

Published by Arcadia Publishing
Charleston SC, Chicago IL, Portsmouth NH, San Francisco CA

Printed in the United States of America

Library of Congress Control Number: 2008942868

For all general information contact Arcadia Publishing at:
Telephone 843-853-2070
Fax 843-853-0044
E-mail sales@arcadiapublishing.com
For customer service and orders:
Toll-Free 1-888-313-2665

Visit us on the Internet at www.arcadiapublishing.com

To Desiree, until we meet again, my greatest friend.

CONTENTS

ACKNOWLEDGMENTS

I want to acknowledge everyone who helped me to compile this work. I would most especially like to thank Amy Frankel, San Francisco Zoo marketing communications manager; Lora LaMarca, director of marketing and public relations; and Gwendolyn Tornatore, public relations manager, for their generous time and help in supplying the majority of the photographs that made this book possible. A very special thanks to Jessie Bushell, Animal Resource Center supervisor, for first believing in me five years ago and guiding me throughout this experience. Thank you to Joe Fitting, education director, and Traci Nappi, education specialist, for their encouraging words and to Harrison Edell, curator of birds, for his photographs. To Christina Moretta of the San Francisco Public Library photo archives for her patience during difficult photograph selections. I express my fondest appreciation to Rayna Garibaldi for her gracious help and direction. To Lisa Hipp for burnt caramel and sticky pots, and to Jennifer Rauch for answering my late night panic phone calls. To my brother, Stephen, for his artistic photographs, and to Mom and Dad for keeping me on track and focused. I would most especially like to thank my editor, John Poultney, for his patience, guidance, and a good laugh every now and then. To San Francisco, my City by the Bay and the greatest in the world.

INTRODUCTION

San Francisco Zoo looks back on the 80-year history of this great San Francisco treasure along the foggy shores of Ocean Beach. It traces the zoo's early years from a place of exotic wildlife used for entertainment purposes to the center of conservation it is today.

In 1922, philanthropist and president of the San Francisco Park Commission Herbert Fleishhacker purchased 60 acres of land from the Spring Valley Water Company at a price of $4,000 per acre. Located in the southwestern corner of San Francisco, the site was transformed into Fleishhacker Pool in 1925. It was the largest outdoor swimming pool in the United States, measuring 1,000 feet in length and 150 feet in width, and lifeguards had to patrol in rowboats. The saltwater pool held regular swim meets where world records were broken, and Johnny Weismuller and Ann Curtis were among the celebrity swimmers that graced the waters. Though barely half of the crowds that flocked to the pool could swim, all seemed to have a great time. American troops also used the pool to exercise military water tactics. Fleishhacker Playfield formed around the pool and included baseball diamonds, tennis courts, the Mother's House, and a train ride on the Little Puffer.

Inspired by a California grizzly bear named Monarch at an exhibit in Golden Gate Park, Fleishhacker decided that he wanted to erect a city zoo on his waterfront location. Fleishhacker Zoo, which opened on June 12, 1929, transferred its first animal exhibits from Golden Gate Park. Among the zoo's first inhabitants were two zebras, one cape buffalo, five rhesus monkeys, two spider monkeys, and three elephants named Babe, Virginia, and Marjorie, donated by Fleishhacker himself. The zoo's basic animal collection attracted few visitors, and original zookeepers were known as "hayburners" because their responsibility was the care and feeding of hoofstock and hay-eating animals. Fleishhacker wanted his zoo to be unlike any other zoo in the country. He got his wish a few months later in 1929 while touring the world with his wife. He stumbled across a wild animal broker in Manila named George Bistany. Bistany thrilled Fleishhacker with his captivating tales of the exotic wildlife that lurked in the jungles. Fleishhacker announced to Bistany, "I'm going to start a real zoo, will you help me to buy the animals and then come to San Francisco to run it?" Bistany agreed and was hired as the zoo's first director.

Bistany channeled his knowledge of basic animal husbandry into building exhibits and training keepers in proper wild animal handling techniques. Park Commission secretary Capt. B. F. Lamb praised Bistany as "a man who knows how to talk to these wild animals and who can tell when they need a bath or a dose of salt." After gracing the zoo with eight years of service, Bistany passed away in 1935 and was succeeded by Edmund Heller. During the Great Depression, Pres. Franklin D. Roosevelt created the Works Progress Administration (WPA) to create jobs and stimulate the economy. Fleishhacker and Heller teamed with architect Lewis Hobart to design 10 WPA exhibits that would eventually form the core of the improved zoo. These included the Lion and Pachyderm Houses, Monkey Island, the Aviary, bear and lion grottos, lakes, fountains, and a restaurant. The open pits with no bars that are seen today were considered innovative at a time when only cages and fences made up animal exhibits in zoos across the nation.

On October 6, 1940, the 10 WPA-funded exhibits, costing $3.5 million, opened to the public for the first time. In the years to follow, the zoo's animal collection expanded and other features were added such as Dentzel Carousel, Southern Pacific Railways Engine 1294, and baby animal petting farms. The most popular attraction proved to be Storyland. Opening in the summer of 1959, this magical 3-acre outdoor playground was filled with play structures inspired by nursery rhymes such as Humpty Dumpty and fairy tale tableaus like the mouse-drawn pumpkin carriage from Cinderella. In the mid-1990s, the beloved but aging Storyland was torn down to make way for new attractions that would eventually become part of the Children's Zoo. These include the Family Farm Petting Zoo, Nature Trail, Animal Resource Center (ARC), and Insect Zoo.

The zoo has undergone additional changes over the years. In 2002, the Mother's House—the building that once served as a place for mothers to relax and care for their children and later as a gift shop for over 20 years—closed, along with the original Sloat Boulevard main entrance. The new entrance off the Great Highway opened shortly thereafter, and new exhibits such as the Lemur Forest and a 3-acre African Savanna followed. The San Francisco Zoo, an accredited member of the American Zoos and Aquariums Association, exhibits a strong commitment to animal welfare through its highly trained veterinary and zookeeper staffs. With almost 250 different species in its care, the zoo today partakes in conservation and education programs that reach the San Francisco community and many other parts of the globe. By inspiring care for all wildlife, the zoo promotes a greater understanding and appreciation for all inhabitants of the planet.

Throughout its rich and colorful history, the zoo has held a special place in the hearts of San Franciscans and other Bay Area residents for 80 years. Visitors of all ages can attest to fond memories of touring the exotic animal exhibits with family and friends, birthday parties at the Children's Zoo, rides on Little Puffer and the zebra train, and hours spent visiting with Storyland's enchanted characters. So on a fine day when you find yourself near Ocean Beach in San Francisco, California, stop by to meet some very special animals, take a ride on a 100-year-old train, discover your role in saving native wildlife, and create some special memories of your own!

One

CONSTRUCTION

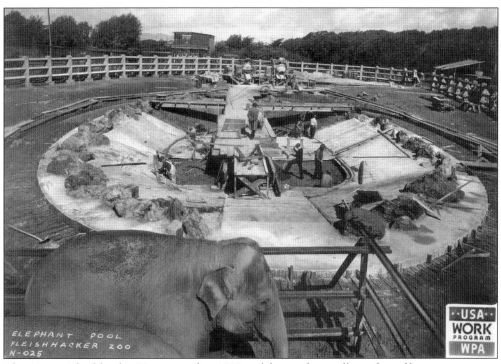

The 48-acre Fleishhacker Zoo opened in 1929 and featured a small number of low-maintenance animals used for entertainment. In response to the Great Depression, Pres. Franklin D. Roosevelt created the Works Progress Administration (WPA) to stimulate the economy and generate jobs. In 1935, WPA funding was received to expand the zoo. Noted zoologist and future director Edmund Heller teamed with architect Lewis Hobart to design 10 WPA exhibits. (Courtesy of the San Francisco Zoo.)

Native San Franciscan Herbert Fleishhacker (1872–1957) was a businessman, civic leader, and philanthropist. He became president of the Board of Park Commission in 1922 and proposed projects to create recreational facilities throughout the city. Upon meeting wild animal broker and future zoo director George Bistany, the two discussed plans for the future Fleishhacker Zoo. Fleishhacker visited the zoo and its animals regularly and knew all the keepers on a first-name basis. (Courtesy of the San Francisco Zoo.)

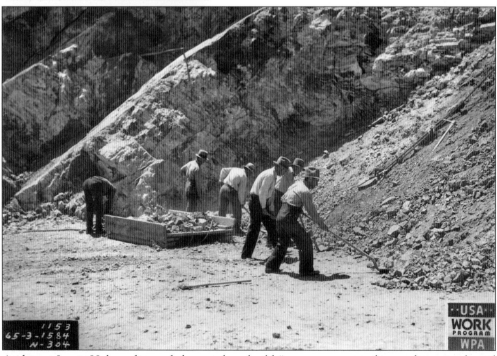

Architect Lewis Hobart directed that workers build "ten structures to house the animals and birds in quarters resembling their native habitats as close as science can devise." (Courtesy of the San Francisco Zoo.)

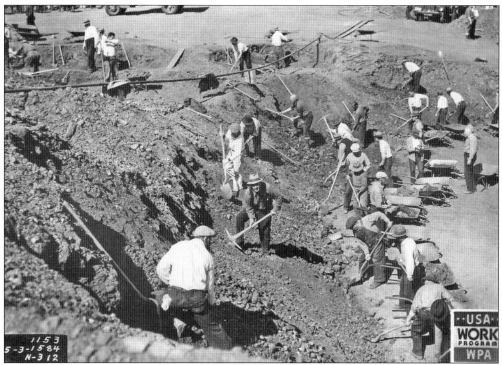

Fleishhacker purchased the 60-acre site due south of Fort Funston from the Spring Valley Water Company in 1922 at a price of $4,000 per acre. He also funded construction of the future Fleishhacker Pool and Playfield. (Courtesy of the San Francisco Zoo.)

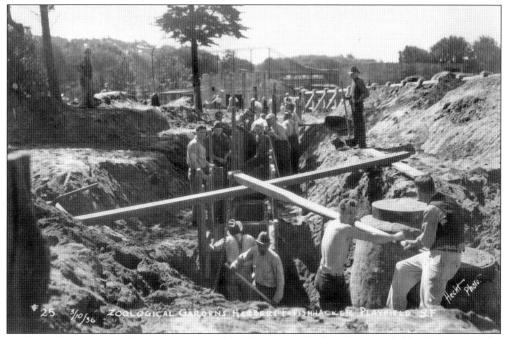

WPA workers excavate the ground in 1936 for the site of Fleishhacker Playfield. (Courtesy of the San Francisco Zoo.)

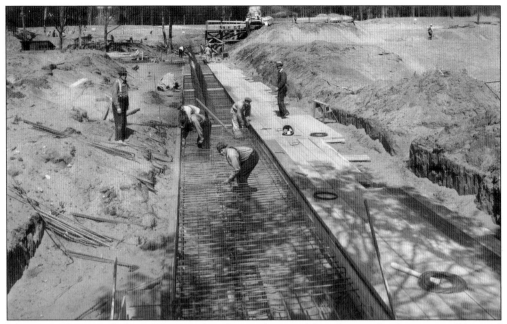

This 1936 photograph shows WPA workers laying the metal foundations for the moat wall located in the .5-acre elephant exhibit. (Courtesy of the San Francisco Zoo.)

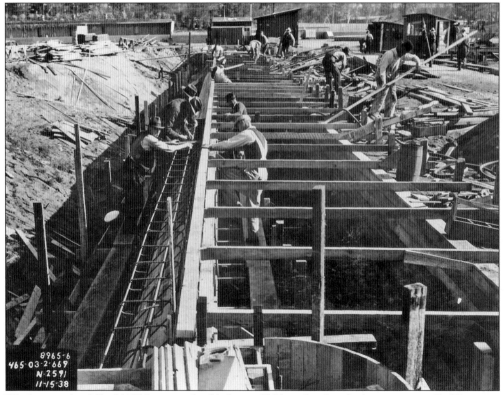

Workers in the fall of 1938 begin to build the scaffolding for the elephant moat wall. (Courtesy of the San Francisco Zoo.)

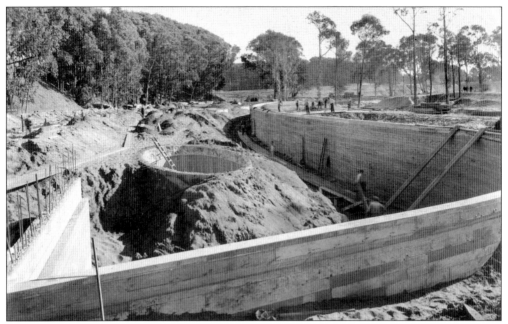

In 1936, construction began on one of the five bear dens located on the northern side of the zoo. (Courtesy of the San Francisco Zoo.)

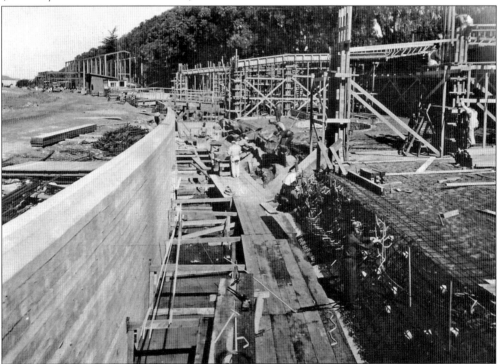

This 1937 photograph depicts the construction of a bear pit. Once completed, these pits were filled with water to provide bears with a place to relax and cool down on those sunny San Francisco days. Note the construction of the Aviary in the upper left corner. (Courtesy of the San Francisco Zoo.)

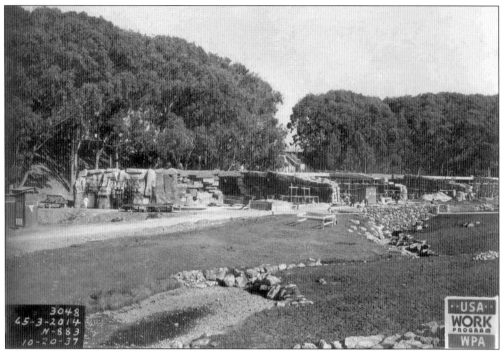

Heller and Hobart directed architects to build a zoo that would be fireproof, permanent, and economical to maintain. The building material used was reinforced concrete, and visitors were provided with an unobstructed view of the animals. (Courtesy of the San Francisco Zoo.)

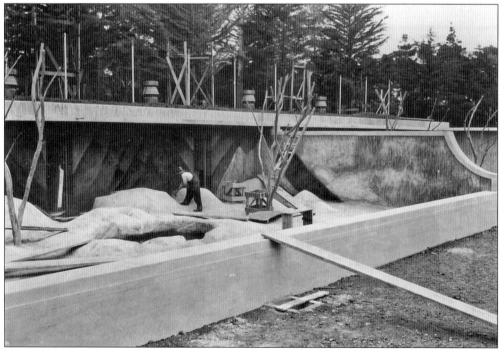

The small pachyderm exhibits were completed in 1938 to house the thick-skinned animals. (Courtesy of the San Francisco Zoo.)

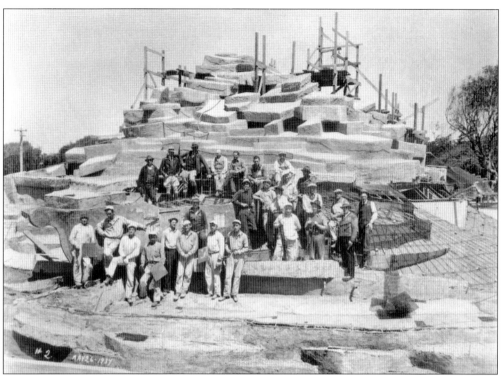

Workers pose in front of the almost completed Monkey Island in 1937. (Courtesy of the San Francisco Zoo.)

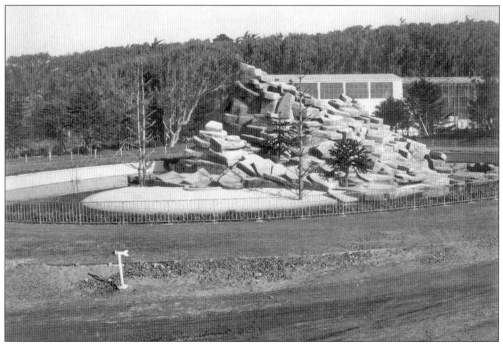

Monkey Island was located in the northern part of the zoo, directly across from the Aviary, which can be seen in the background of this 1940 photograph. (Courtesy of the San Francisco Zoo.)

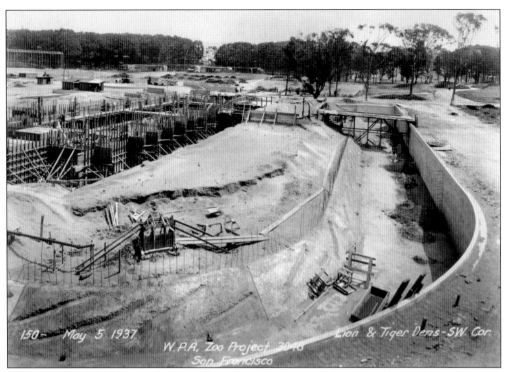

Taken in 1937, this photograph shows the early construction of the lion and tiger dens. (Courtesy of the San Francisco Zoo.)

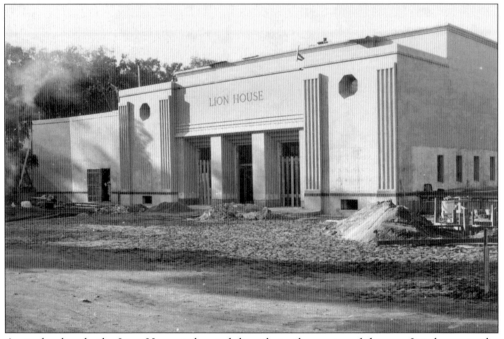

A city landmark, the Lion House is located directly in the center of the zoo. It is home to the big cats and the place where millions of visitors came to observe the daily feedings. (Courtesy of the San Francisco Zoo.)

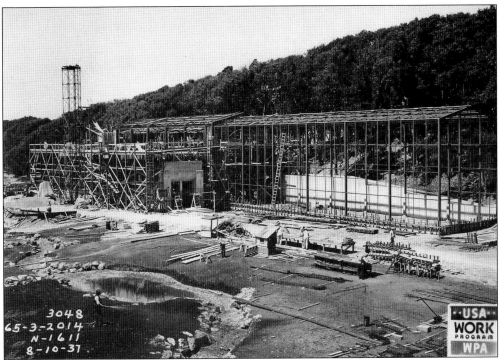

Aviary scaffolding rises in 1937. (Courtesy of the San Francisco Zoo.)

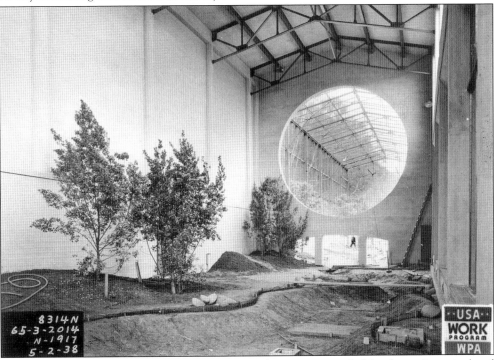

This inside view of the Aviary displays the tremendous space provided for the zoo's tropical and aquatic birds. Pelicans flew between the inside and outside through the large circle pass. (Courtesy of the San Francisco Zoo.)

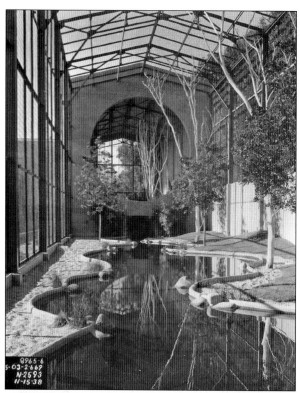

The Aviary was designed in 1938 to provide birds with a naturalistic setting, such as this indoor river. (Courtesy of the San Francisco Zoo.)

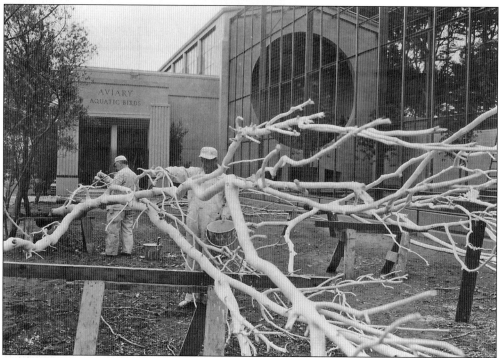

Workers in 1938 stand outside of the completed Aviary and paint synthetic trees that will be used to decorate its interior. (Courtesy of the San Francisco Zoo.)

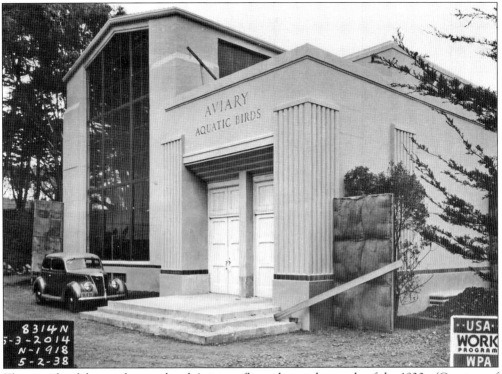

The outside of the nearly completed Aviary reflects the art deco style of the 1930s. (Courtesy of the San Francisco Zoo.)

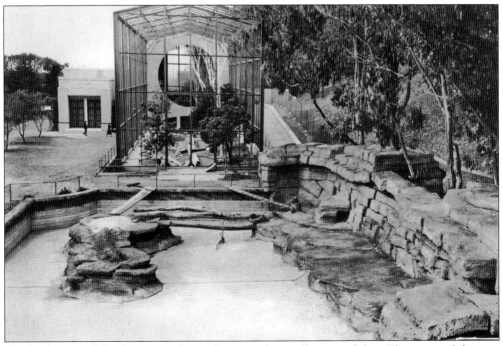

The back wing of the Aviary was located next to the small mammal den. The mammal den was later filled with water and served as the seal exhibit. (Courtesy of the San Francisco Zoo.)

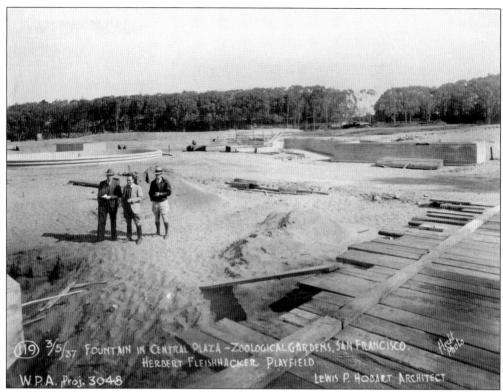

Architects stand in front of the Central Plaza fountain and look out on the future site of the Lion House. (Courtesy of the San Francisco Zoo.)

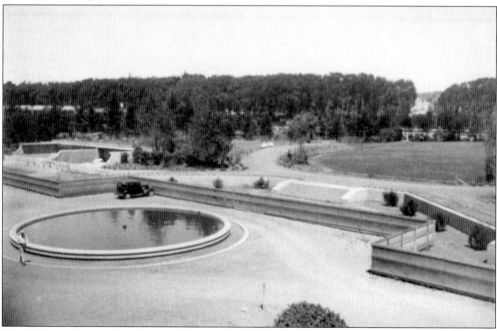

This alternate view of the Central Plaza fountain displays the small pachyderm exhibits on the left. (Courtesy of the San Francisco Zoo.)

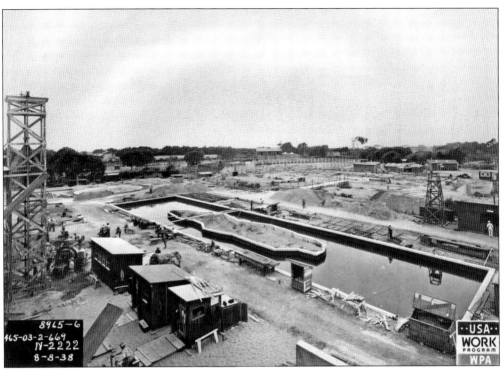

A small lake was located between the Lion House and elephant exhibit. Scaffolding for the elephant exhibit can be seen in this view from 1938. (Courtesy of the San Francisco Zoo.)

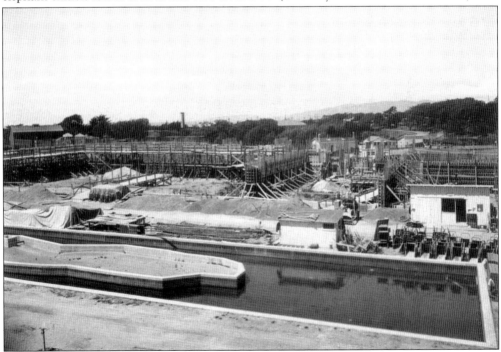

Progress is made on the elephant exhibit as the outer moat walls rise. (Courtesy of the San Francisco Zoo.)

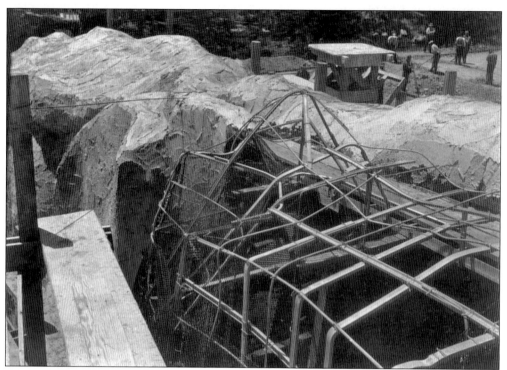

Workers plastered the internal framing of the artificial rocks with concrete. These rocks, which formed the barriers of the lion and bear dens, remain in use today. (Courtesy of the San Francisco Zoo.)

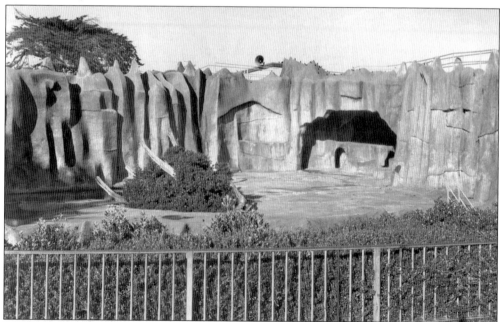

Heller and Hobart's popular pits with no bars, like the one seen here in the lions' den, were considered innovative at a time when only cages and fences were found in other zoos. (Courtesy of the San Francisco Zoo.)

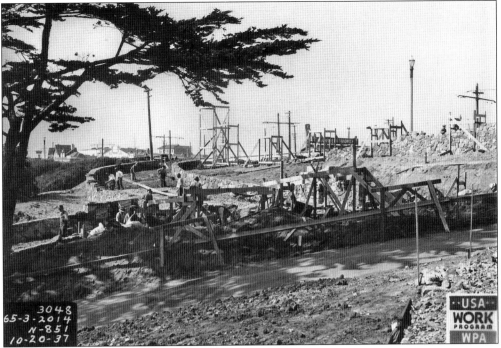

This 1937 photograph shows the early construction and scaffolding of the Sloat Boulevard entrance to the zoo. (Courtesy of the San Francisco Zoo.)

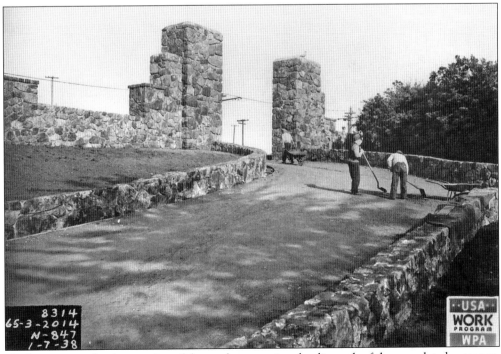

Workers prepare for the opening of the zoo by grooming the dirt path of the completed entrance. (Courtesy of the San Francisco Zoo.)

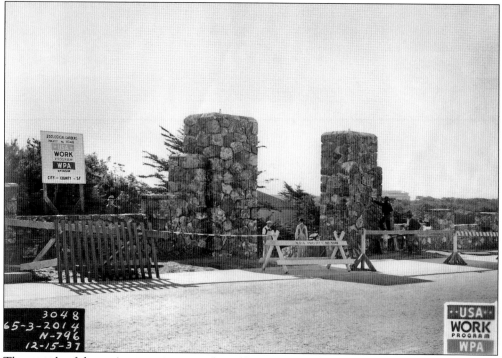

The outside of the zoo's entrance is seen from Sloat Boulevard. Note the WPA construction sign on the upper left. (Courtesy of the San Francisco Zoo.)

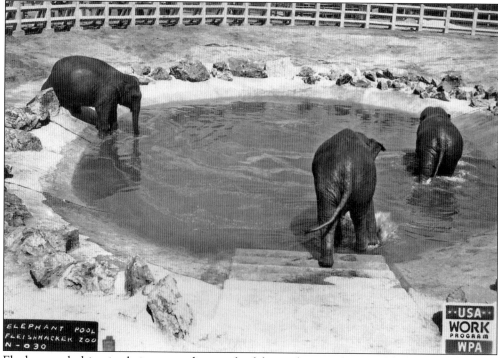

Elephants splashing in their new wading pool celebrate the completion of the zoo in the 1940s. Total construction costs exceeded $3.5 million. (Courtesy of the San Francisco Zoo.)

Two

FLEISHHACKER ZOO

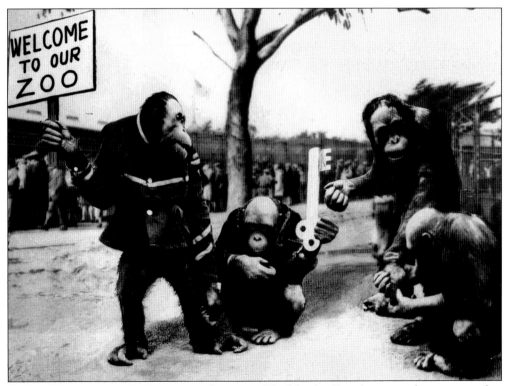

Orangutans in 1931 invite visitors into the private Fleishhacker Zoo that opened two years earlier in 1929. This early zoo predated the construction of the 10 WPA exhibits and was located on 48 acres belonging to Herbert Fleishhacker. (Courtesy of the San Francisco Zoo.)

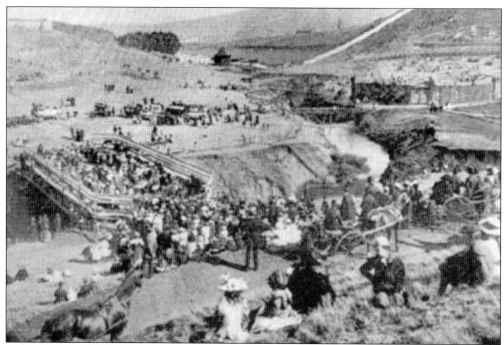

Gold Rush tycoon Robert B. Woodward opened Woodward's Gardens on May 4, 1866. Located in the Mission District at Valencia and Fifteenth Streets, the 4-acre playground served as a place for families to sail, skate, and enjoy beautiful gardens and concerts. The captivating animal collection consisted of black swans, deer, a sea lion pond, bear grottos, and an aviary. The city closed Woodward's Gardens in 1890 and divided the property into building lots. (Courtesy of the San Francisco Zoo.)

Monarch was a California grizzly whose relationship with San Francisco began in 1889 when founder of the *San Francisco Examiner* William Randolph Hearst challenged reporter Allen Kelly to find a live grizzly. Lured into a catch pen by honey and mutton, Monarch was captured and welcomed at the Townsend Street train station by a crowd of over 20,000 people. (Courtesy of the San Francisco Zoo.)

Monarch lived in Woodward's Gardens for a year before moving to Golden Gate Park, where he sired two cubs. He became an admired figure in the eyes of many San Franciscans, as he exemplified the importance of conserving the disappearing native wildlife. Monarch lived for 16 years, although he never resided in the zoo's current location at Ocean Beach. After his death, the remains were sent to the California Academy of Sciences for mounting. His image was used as a model for the California state flag. Monarch touched Fleishhacker's heart, inspiring him to establish a city zoo. (Courtesy of the San Francisco Zoo.)

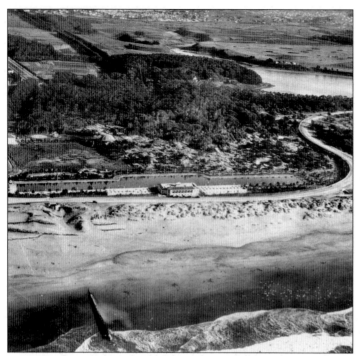

The Fleishhacker Municipal Swimming Pool, completed in 1925 after two and a half years of construction and planning, was appropriately named after its donor, Herbert Fleishhacker. It was the largest outdoor pool in the world at the time, measuring 1,000 feet in length and 150 feet in width. While the swimming pool was the primary feature, Fleishhacker Playfield also included several baseball diamonds and 16 tennis courts. Construction cost totaled $750,000. (Courtesy of the San Francisco Zoo.)

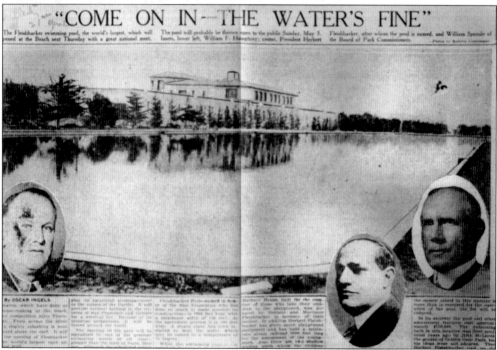

This newspaper article was published shortly before the pool opened to the public on May 3, 1925. Five thousand swimmers and spectators, paying 25¢ for adults and 15¢ for children, attended the opening day national swim meet. Fleishhacker is pictured in the center along with San Francisco Board of Park Commissioners William F. Humphrey and William Sproule. (Courtesy of the San Francisco Zoo.)

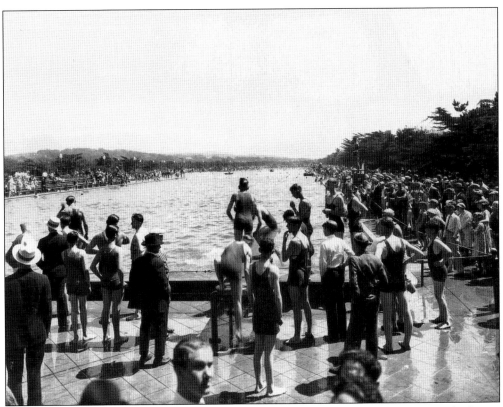

The pool held 6 million gallons of seawater pumped in directly from the adjoining Pacific Ocean and accommodated 10,000 bathers. A steam plant was installed to heat the saltwater pool to a comfortable 75 degrees. (Courtesy of the San Francisco Zoo.)

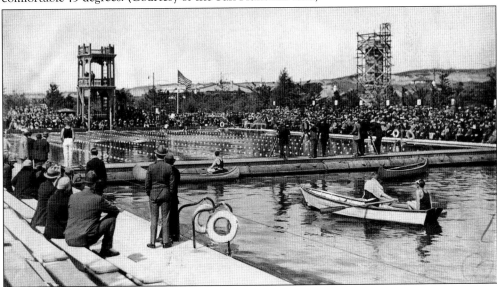

Twelve lifeguards were always on duty and some patrolled the pool in rowboats, due to its enormous size. Local teens were hired as instructor aids to assist children in the pool. (Courtesy of the San Francisco History Center, San Francisco Public Library.)

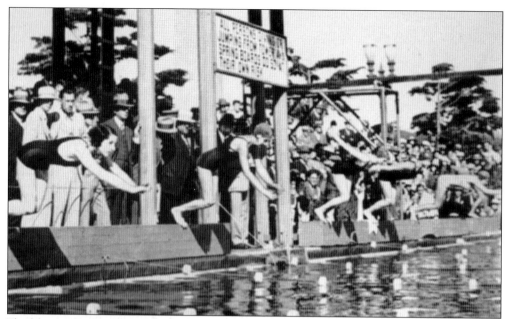

Fleishhacker Pool held regular swim meets, water polo and synchronized swimming tournaments, and diving competitions. People gathered from all over to watch performers dive from one of the pool's three diving platforms. (Courtesy of the San Francisco Zoo.)

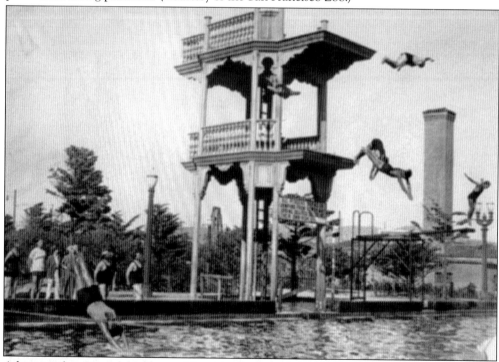

Admission fees granted a day's use of the grounds, large dressing rooms with showers, and the loan of a bathing suit and large towel, sterilized between uses. Though fewer than half the bathers could swim, the *San Francisco Chronicle* reported that all seemed to have a marvelous time. (Courtesy of the San Francisco Zoo.)

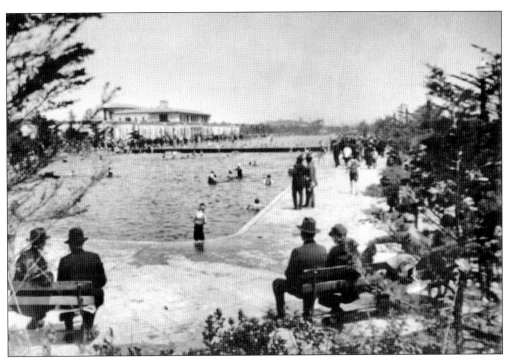

The pool house resided in between tree-sheltered parts of Ocean Beach and Fleishhacker Pool. Pool patrons could easily travel between both locations. The pool house also contained a cafeteria and a childcare center in the main building. (Courtesy of the San Francisco Zoo.)

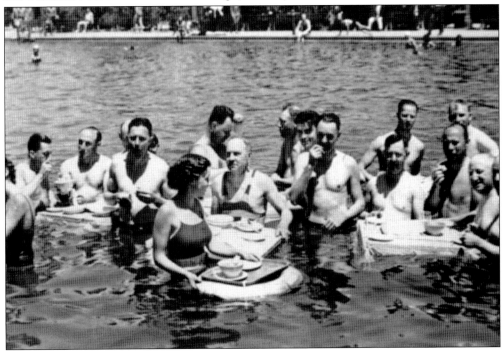

Members of the Mutual Business Club engage in the Businessman's Lunch in May 1936. (Courtesy of the San Francisco Zoo.)

Eighteen-year-old native San Franciscan and Olympic swimming champion Ann Curtis set the women's world record on July 30, 1944, at Fleishhacker Pool for the 880-yard freestyle swim. She beat the 1937 record by eight seconds, finishing in a time of 11 minutes and 8 seconds. Johnny Weismuller was among other celebrity swimming stars in the 1940s who entertained crowds. (Courtesy of the San Francisco History Center, San Francisco Public Library.)

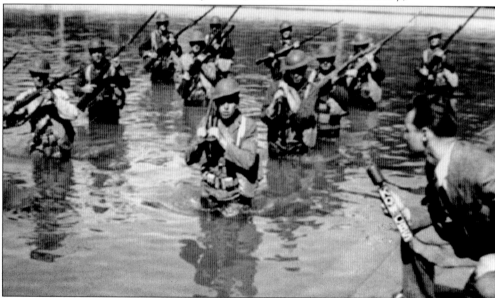

CBS-KQW reporter Dave Vaile explains American military activity in the pool during the MacArthur Day celebration. In this particular exercise, trainees practice stream-fording tactics in which they keep their guns dry while wading across a difficult water obstacle. (Courtesy of the San Francisco Zoo.)

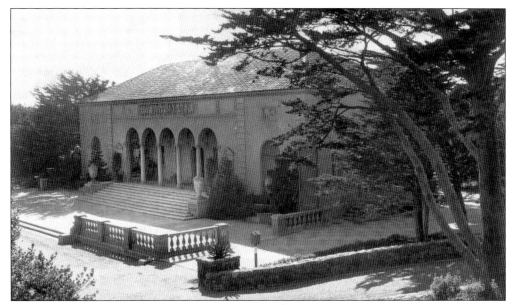

Fleishhacker and his brother Mortimer donated over $50,000 for the construction of the Mother's House, designed by architect George W. Kelham. Opening on Labor Day of 1925, it fulfilled its purpose of providing mothers visiting the playground with a resting place to care for their children. In the late 1960s, the name was changed to the Mother's Building and it served as the zoo's main gift shop until closing in 2002. (Courtesy of the San Francisco Zoo.)

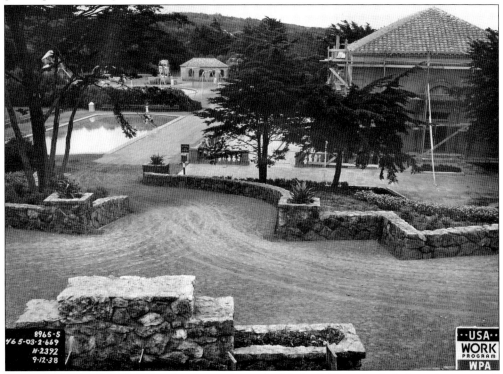

Located near the Sloat Boulevard main entrance, the Mother's House included an adjacent small outdoor wading pool. (Courtesy of the San Francisco Zoo.)

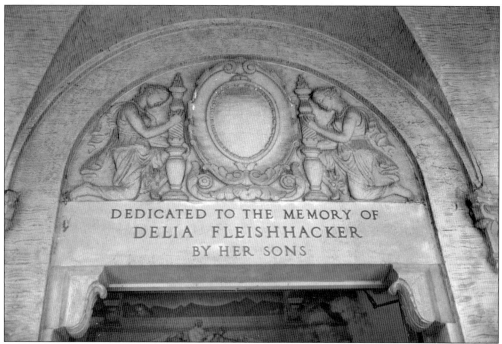

The Fleishhacker brothers dedicated the house to their mother, Delia, who died a few years before the zoo was established. (Courtesy of the San Francisco Zoo.)

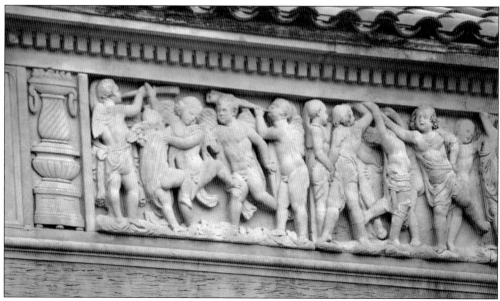

Built as a WPA project, the Mother's House was constructed in the Italian Renaissance style found in Tuscany in the 1600s. The single-story, rectangular building towers 24 feet high. The exterior walls and cherub relief found on the top are stucco, and the roof is topped with red mission tiles. (Courtesy of the San Francisco Zoo.)

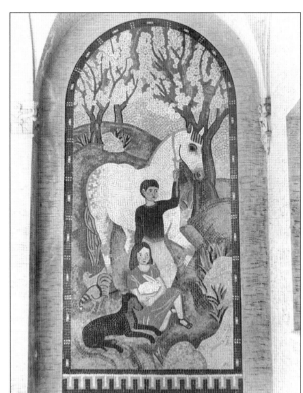

The exterior walkway into the Mother's House contains sidewalls ornamented with two mosaic murals depicting the city's namesake, St. Francis, and children with animals. Sisters Ester, Helen, and Margaret Bruton created this lovely artwork for the Public Works of Art Project established to employ artists under President Roosevelt's New Deal. (Courtesy of the San Francisco Zoo.)

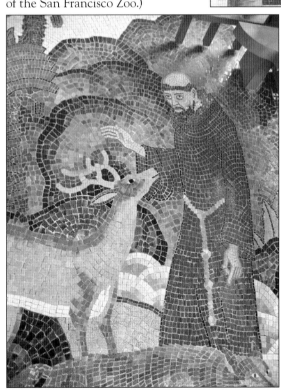

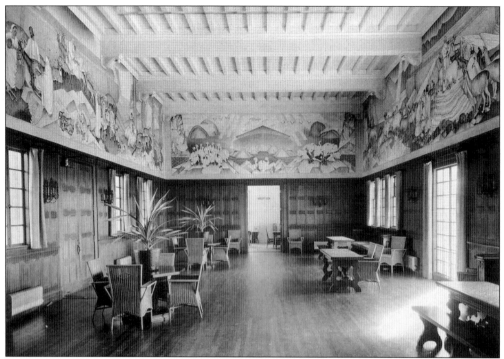

The Mother's House contained an open central space with a floor made of rich brown hardwood, a nursery, and two tearooms. (Courtesy of the San Francisco Zoo.)

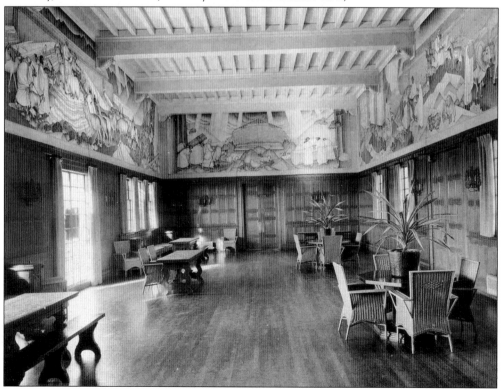

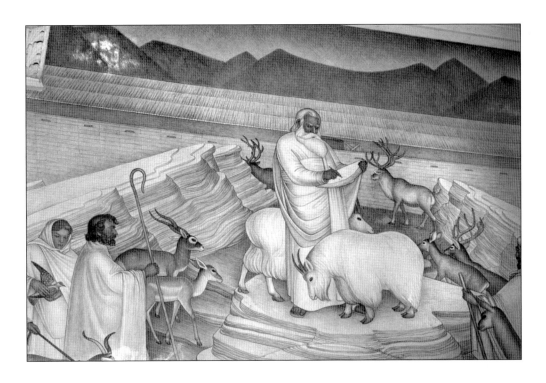

The four indoor murals painted by Helen K. Forbes and Dorothy W. Puccinelli were also part of the Public Works of Art Project. These vivid murals illustrate the tale of Noah and his ark. (Courtesy of the San Francisco Zoo.)

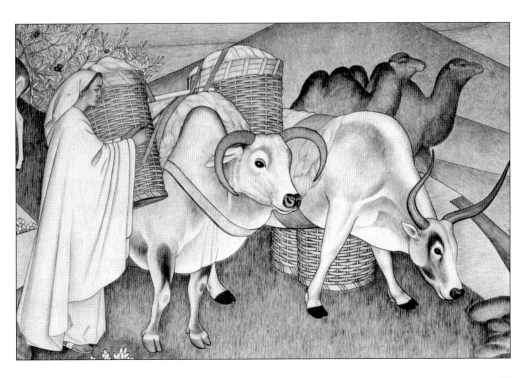

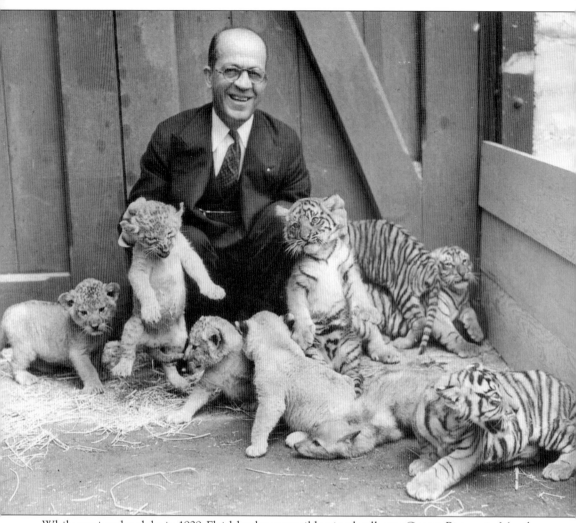

While touring the globe in 1929, Fleishhacker met wild animal collector George Bistany in Manila and hired him to expand the zoo's animal collection. Bistany was quickly accepted by employees and became the zoo's first director. He channeled his knowledge of basic animal husbandry into building exhibits and training keepers in proper wild animal handling techniques. After gracing the zoo with eight years of service, Bistany passed away in 1935 and was succeeded by Edmund Heller. (Courtesy of the San Francisco Zoo.)

Bistany directs two chimps and a young elephant in 1931. (Courtesy of the San Francisco Zoo.)

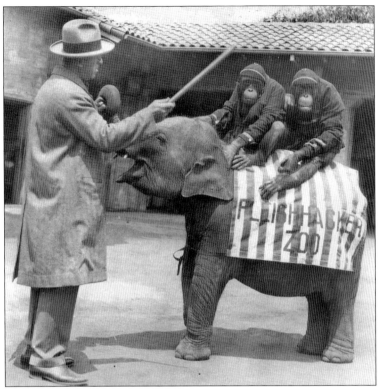

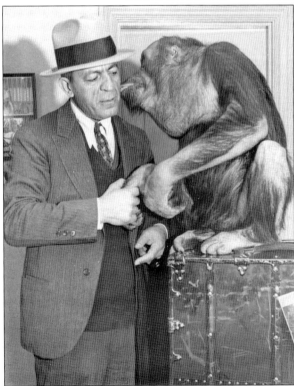

The early zoo comprised mostly low maintenance animals such as buffalo, horses, and elephants. This changed when Bistany (pictured) became director and took overseas trips to obtain exotic animals, such as this orangutan. (Courtesy of the San Francisco Zoo.)

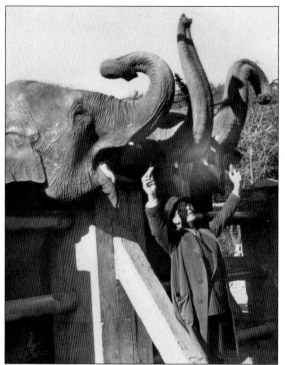

San Francisco flew into panic when it learned Bistany (pictured) was expecting a shipment of leopards, tigers, lions, and elephants. The city believed the zoo lacked both the adequate facilities and the expertise to handle these untamed animals. Bistany personally managed the animals' shipment, improved cages, and delivered impromptu lectures about caring for each species. Within a short time, the animals were well tended and healthy. (Courtesy of the San Francisco Zoo.)

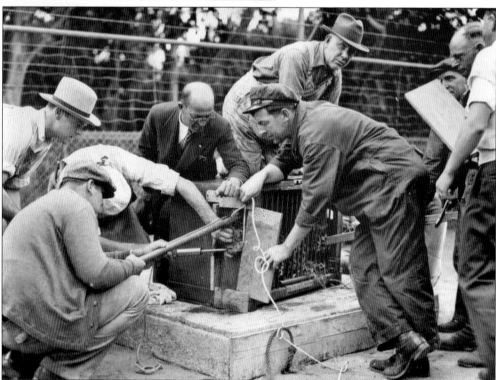

Bistany (pictured center without hat) and zookeepers release a leopard from a makeshift crate into its new zoo enclosure. (Courtesy of the San Francisco Zoo.)

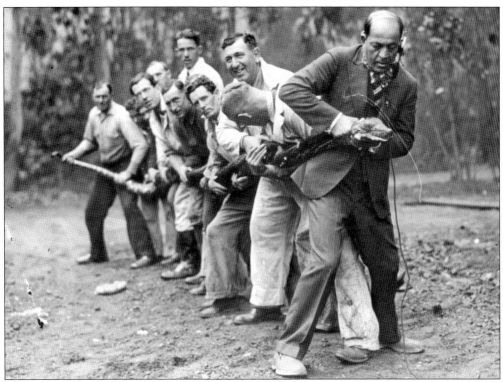

Ten keepers and Bistany (pictured at right) handle a large python. (Courtesy of the San Francisco Zoo.)

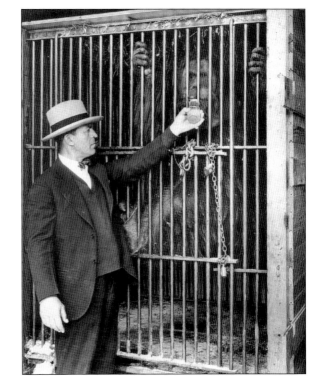

Bistany was known for his watchword: cleanliness. Whether in the kitchen, hospital, or an animal exhibit, he placed a special stress upon keeping the zoo and cages spotless. (Courtesy of the San Francisco Zoo.)

Bistany's top priority and main pride was the well-being and care of the zoo's animals, like this lion cub. Park Commission secretary Capt. B. F. Lamb praised Bistany as "a man who knows how to talk to these wild animals and who can tell when they need a bath or a dose of salt." (Courtesy of the San Francisco Zoo.)

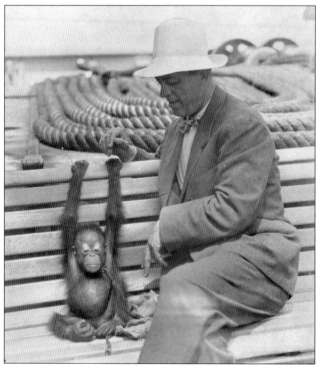

Determined to turn the San Francisco Zoo into a well-known facility, Bistany took progressive steps, such as setting up breeding programs for the exotic animals. (Courtesy of the San Francisco Zoo.)

A Fleishhacker zookeeper in the 1930s restrains the boxing kangaroo. (Courtesy of the San Francisco Zoo.)

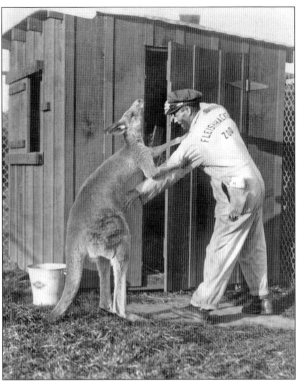

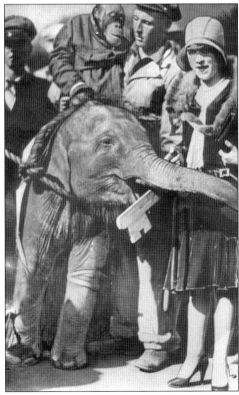

Visitors would often pose for photographs when zookeepers took animals out for an afternoon stroll. (Courtesy of the San Francisco Zoo.)

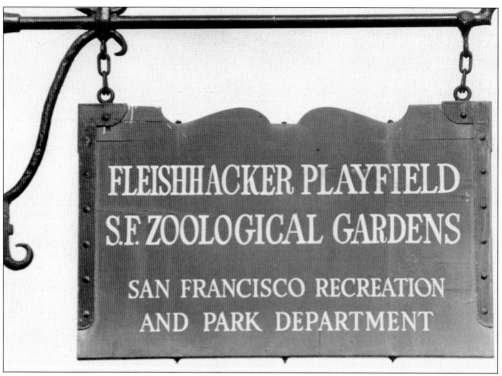

The Fleishhacker Playfield sign was located in front of the Sloat Boulevard entrance. It was removed in 1941 when the zoo changed its name to the San Francisco Zoological Gardens. (Courtesy of the San Francisco Zoo.)

Visitors poured into the zoo on opening day for all WPA exhibits on October 6, 1940. Attending the zoo was free until 1968 when admission was raised to 25¢. In 1979, admission rose again to the exorbitant price of $1. (Courtesy of the San Francisco Zoo.)

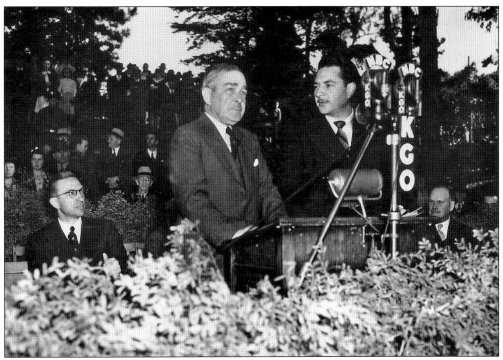

Opening day speeches were broadcast live on KGO radio. (Courtesy of the San Francisco Zoo.)

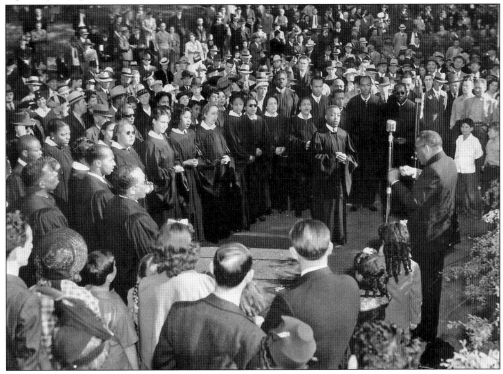

A local choir entertains the eager visitors during the opening day celebration. (Courtesy of the San Francisco Zoo.)

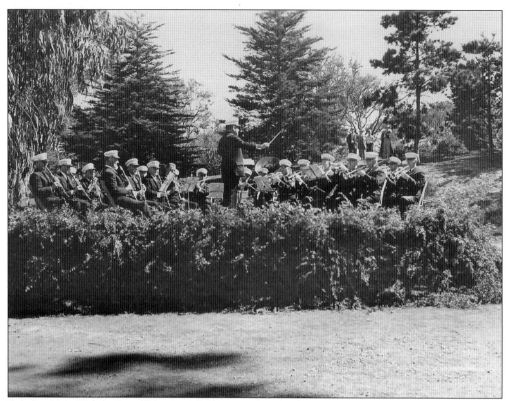

Band performances also add to the opening day excitement. (Courtesy of the San Francisco Zoo.)

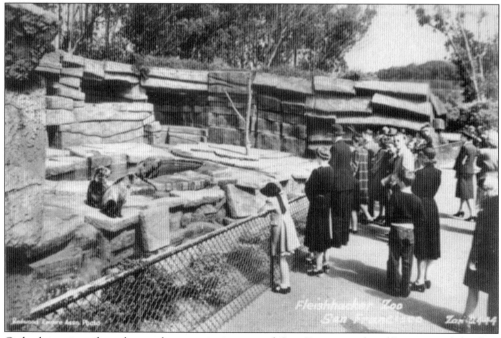

Onlookers view three brown bears enjoying a cool San Francisco day. (Courtesy of the San Francisco Zoo.)

Two female lions catch the eyes of a large crowd. (Courtesy of the San Francisco Zoo.)

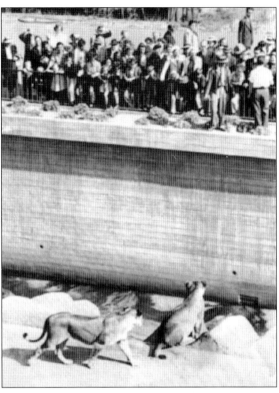

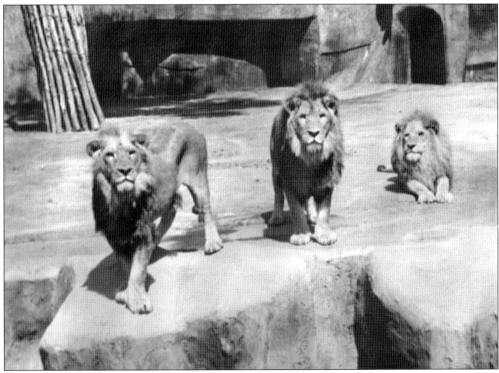

A large crowd catches the eyes of a pride of lions. (Courtesy of Harrison Edell.)

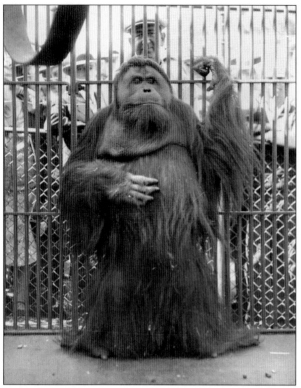

Sultan, the giant orangutan, was born in Borneo in 1911 and was donated by Santa Barbara tycoon Christian Holmes (heir of the Fleischmann Yeast fortune) in 1930. Sultan died in April 1931, but his body was sent to the California Academy of Sciences for mounting. Behind Sultan stands spectator Fred Chatlon. (Courtesy of the San Francisco Zoo.)

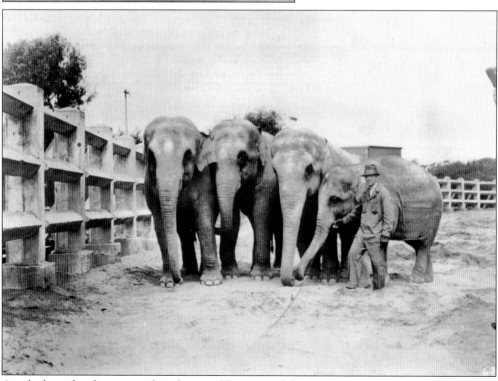

An elephant family poses with its keeper. (Courtesy of the San Francisco Zoo.)

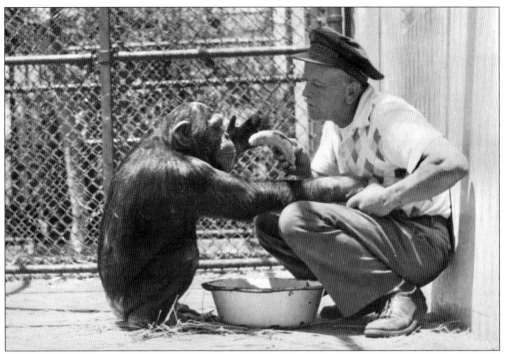

The beloved chimp Bimbs accepts a well-deserved banana from his keeper. (Courtesy of the San Francisco Zoo.)

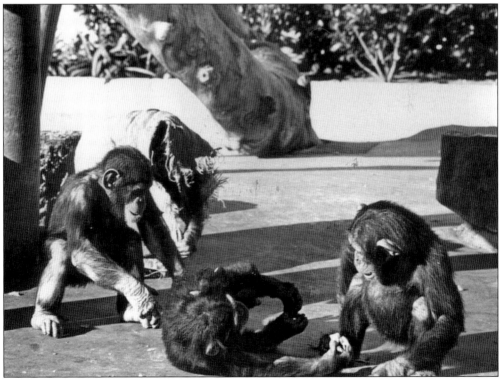

Three chimps play monkey games. (Courtesy of the San Francisco Zoo.)

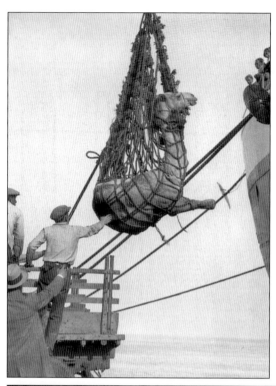

Part of Bistany's exotic animal collection, a camel arrives at the Port of San Francisco in 1929. (Courtesy of the San Francisco Zoo.)

This rare double-humped camel is far from his home in Asia. (Courtesy of the San Francisco Zoo.)

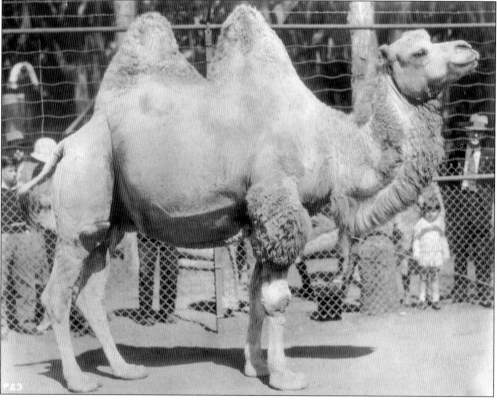

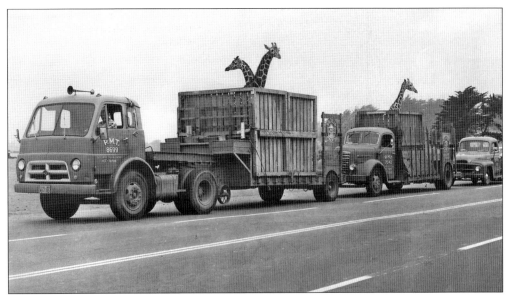

Giraffes, on their way to the zoo, motor down Skyline Boulevard. (Courtesy of the San Francisco Zoo.)

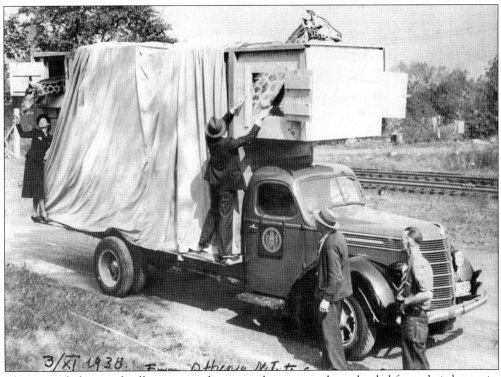

The new inhabitants finally arrive at the zoo and prepare to be unloaded from their long trip. (Courtesy of the San Francisco Zoo.)

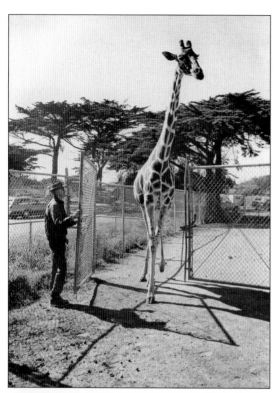

The giraffe enters its new home at the zoo. (Courtesy of the San Francisco Zoo.)

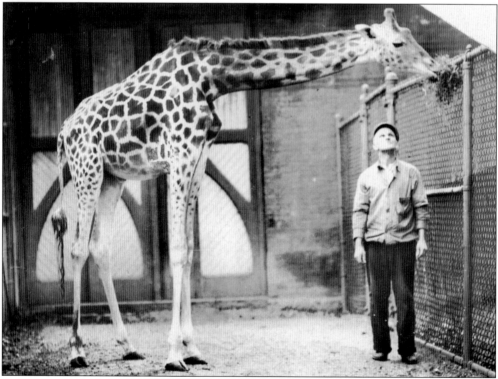

A 1932 keeper feeds a giraffe in the shelter. (Courtesy of the San Francisco Zoo.)

Keeper John "Jockey" Cotton rides a giraffe in this unusual 1964 photograph. (Courtesy of the San Francisco Zoo.)

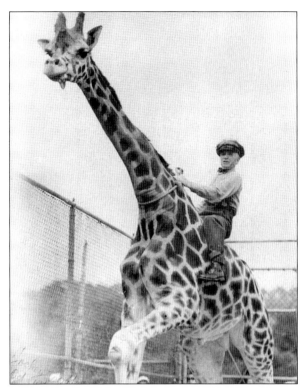

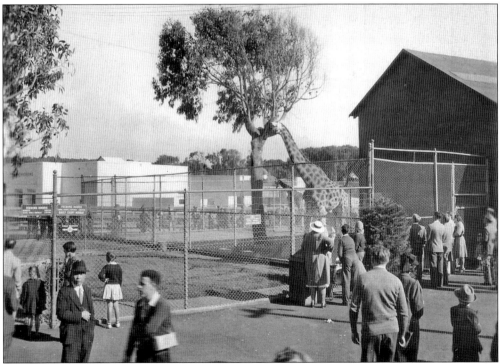

Curious onlookers surround the exterior of the giraffe stable. (Courtesy of the San Francisco Zoo.)

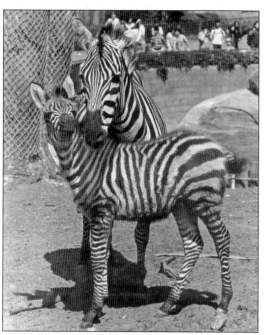

A mother and baby zebra nuzzle together while spectators peer through the enclosure. (Courtesy of the San Francisco Zoo.)

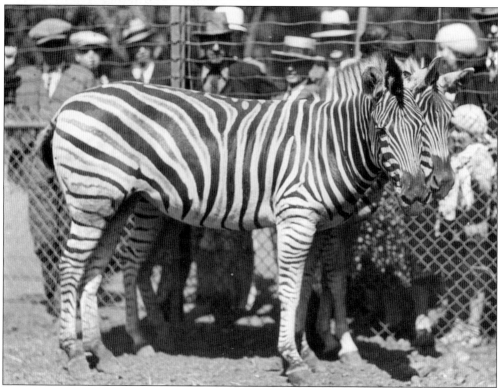

Two zebras pose in front of a crowd in 1932. Zebras have always been a part of the zoo's animal collection because they are low maintenance compared to exotic animals. Original zookeepers were known as "hayburners" because their responsibility was the care and feeding of hay-eating animals such as zebras. (Courtesy of the San Francisco Zoo.)

Two off-duty sailors embrace a baby polar bear. (Courtesy of the San Francisco Zoo.)

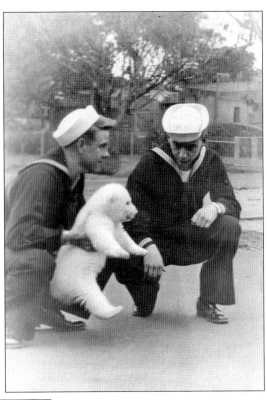

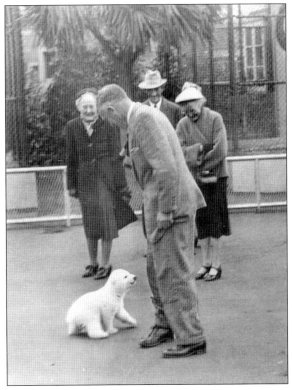

Zoo patrons stroll with the baby polar bear in 1954. (Courtesy of the San Francisco Zoo.)

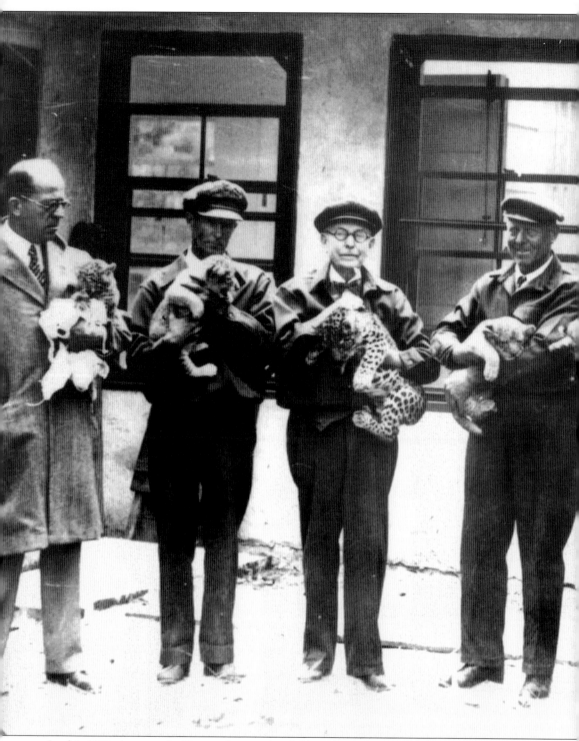

In this 1933 photograph, Bistany (pictured at left) poses with eight other keepers to welcome the arrival of 10 lion, leopard, and other feline cubs to Fleishhacker Zoo. Of the zoo's 46 baby animals, 30 of them were cats. Bistany's breeding program proved successful, and the zoo soon

adopted birth-control programs for its expanding population. Bistany claimed the zoo had one of the largest collections of baby animals in the world. (Courtesy of the San Francisco Zoo.)

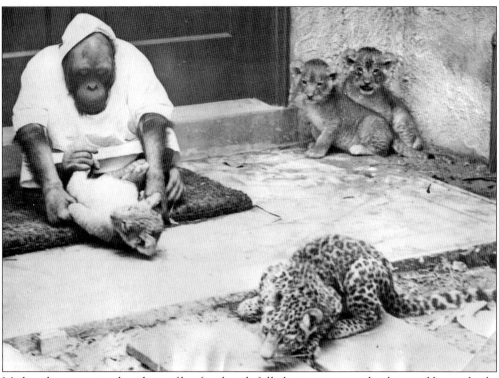

Mickey the orangutan has three of his four hands full playing nursemaid to lion and leopard cubs in the summer of 1931. (Courtesy of the San Francisco Zoo.)

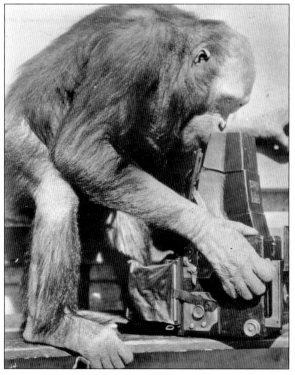

An adult orangutan peers through the lens of a camera. (Courtesy of the San Francisco Zoo.)

The beloved orangutan Mickey befriends Scout Jack Bradinan of Troop 20 in 1931. (Courtesy of the San Francisco Zoo.)

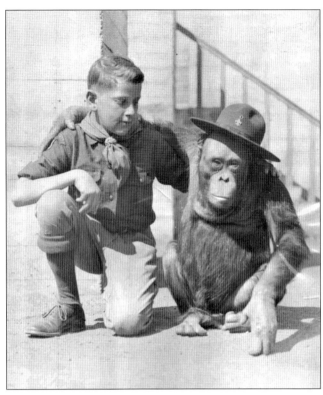

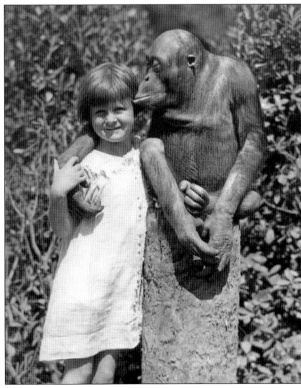

An orangutan puckers up to give this smiling zoo-goer a kiss. (Courtesy of the San Francisco Zoo.)

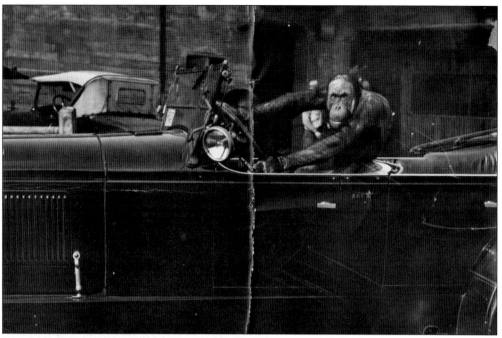

Orangutan Mickey is ready for life in the fast lane. (Courtesy of the San Francisco Zoo.)

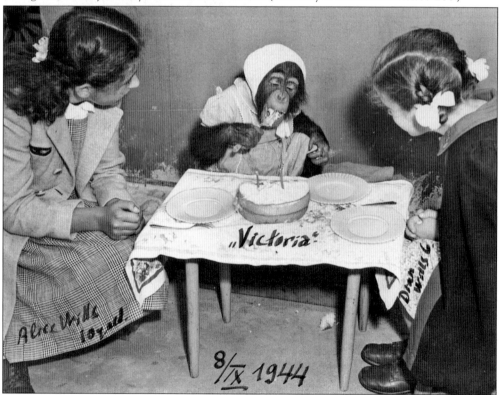

Victoria the chimpanzee shares a little cake party with sisters Alice (age 10) and Dian Wills (age 6) in the fall of 1944. (Courtesy of the San Francisco Zoo.)

Dressed like Santa Claus, orangutan Mickey straddles atop the young elephant named May. (Courtesy of the San Francisco Zoo.)

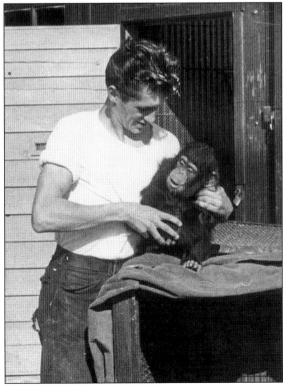

Keeper Will Wells poses with chimpanzee friend Bimbo in 1937. (Courtesy of the San Francisco Zoo.)

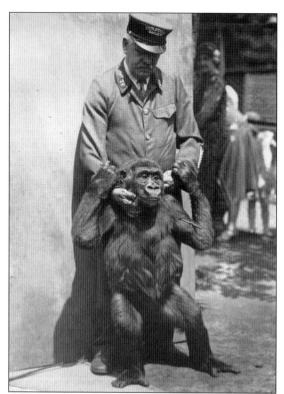

A four-year-old gorilla embraces his animal keeper. (Courtesy of the San Francisco Zoo.)

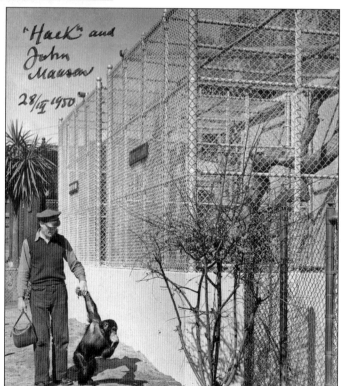

John Mansen escorts Hack the chimpanzee to his new exhibit in 1950. (Courtesy of the San Francisco Zoo.)

This little monkey avidly reads to discover more information about his family tree. (Courtesy of the San Francisco Zoo.)

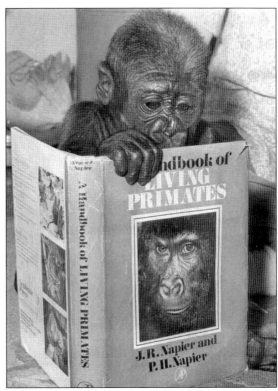

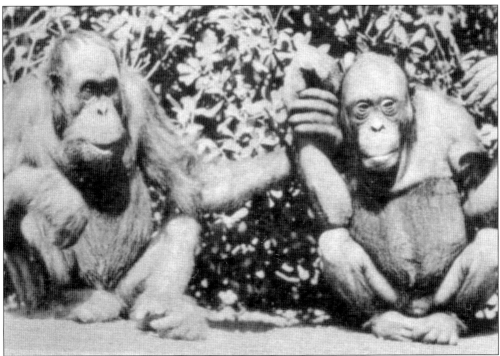

The zoo distributed this postcard showing two adult orangutans in the early 1930s. (Courtesy of the San Francisco Zoo.)

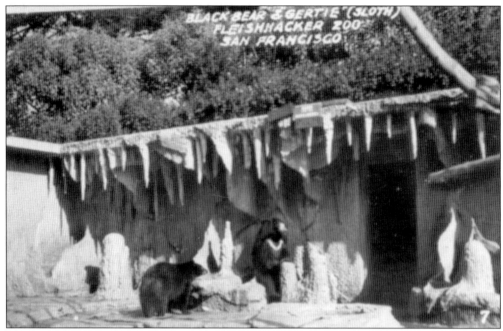

This postcard shows how exhibits, such as the bear grottos, were designed to resemble animals' natural habitats. (Courtesy of the San Francisco Zoo.)

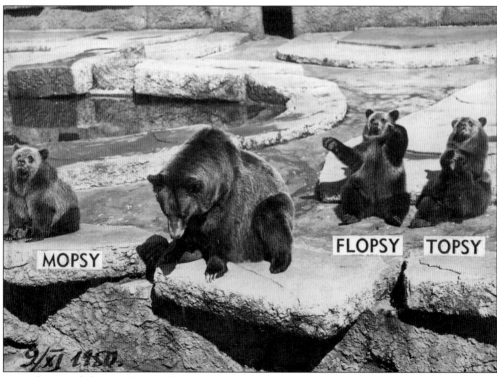

A mother grizzly bear gathers with cubs Mopsy, Flopsy, and Topsy in 1950. (Courtesy of the San Francisco Zoo.)

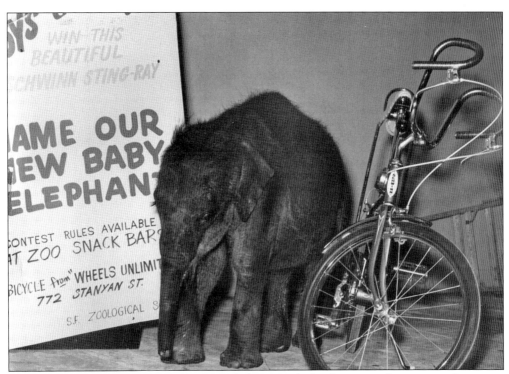

Contests were held for zoo guests to name baby animals. In this particular contest, the person who submitted the winning entry received a new Schwinn banana-seat bicycle. (Courtesy of the San Francisco Zoo.)

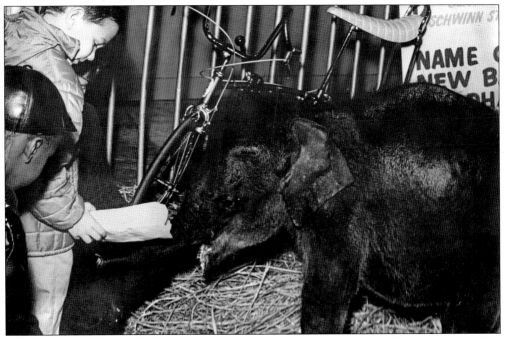

A boy hoping to win the bike shows the unnamed elephant his entry. (Courtesy of the San Francisco Zoo.)

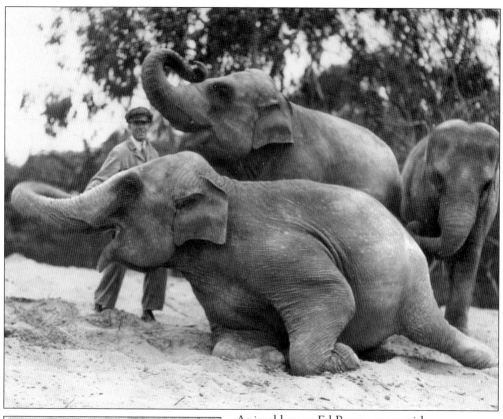

Animal keeper Ed Brown poses with Asian elephants Marjorie, Virginia, and Babe, who were originally donated to the zoo by Herbert Fleishhacker in 1925. (Courtesy of the San Francisco Zoo.)

Tasty treats like these could be purchased at snack stands for just peanuts! (Courtesy of the San Francisco Zoo.)

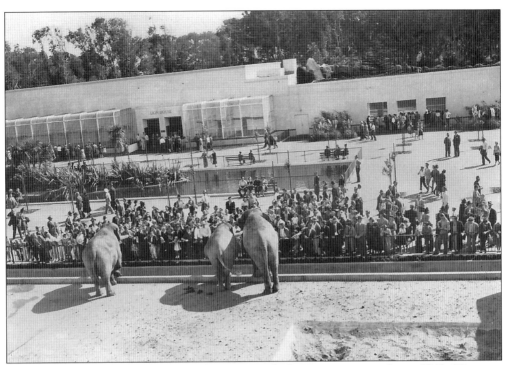

Excited spectators congregate before the majestic elephants on opening day in 1940. (Courtesy of the San Francisco Zoo.)

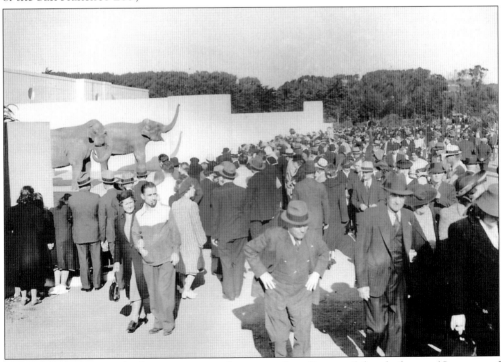

Large crowds on opening day squeeze together to catch a glimpse of the elephants. (Courtesy of the San Francisco Zoo.)

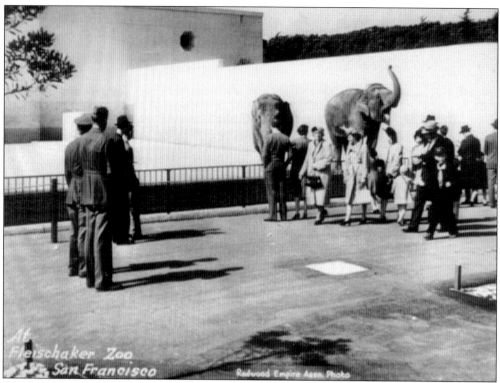

This 1940s postcard shows a typical day at the elephant exhibit. (Courtesy of the San Francisco Zoo.)

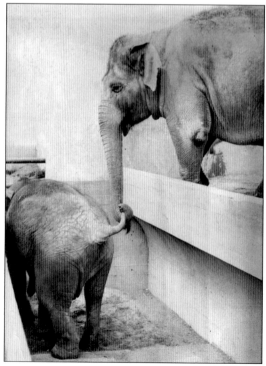

A mother elephant tenderly dotes on her young calf in the moat. (Courtesy of the San Francisco Zoo.)

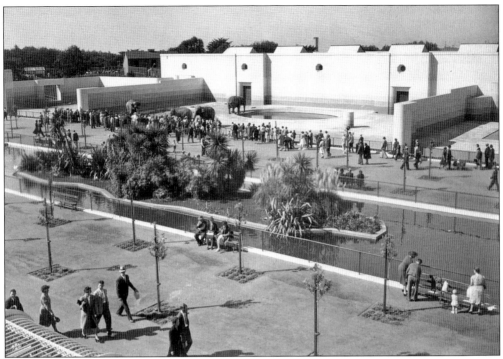

This photograph, taken from the Lion House, displays a wide view of the elephant exhibit and pond. (Courtesy of the San Francisco Zoo.)

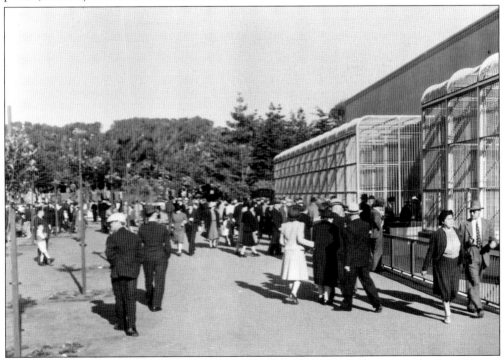

People get a closer look at the animals in the small cages located adjacent to the Lion House. (Courtesy of the San Francisco Zoo.)

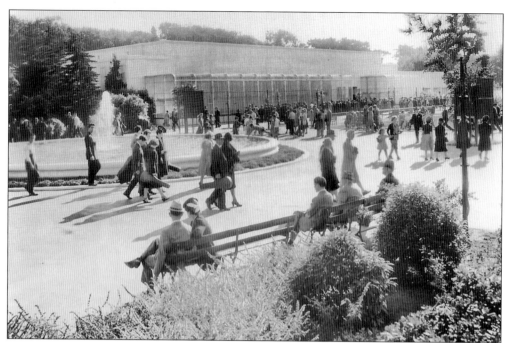

Patrons relax on a bench and gaze across the central fountain. (Courtesy of the San Francisco Zoo.)

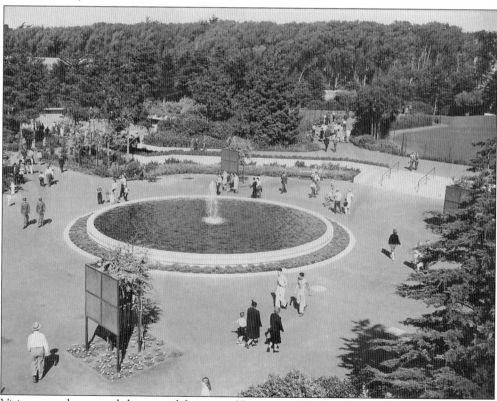

Visitors wander around the central fountain. (Courtesy of the San Francisco Zoo.)

A Kodiak bear stands with her three new cubs. (Courtesy of the San Francisco Zoo.)

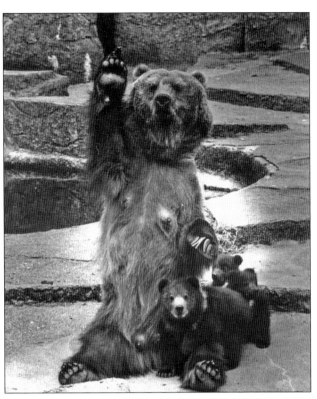

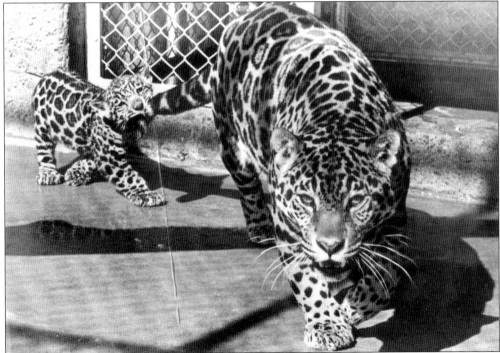

This jaguar cub playfully tugs its mother's tail and follows closely behind her. (Courtesy of the San Francisco Zoo.)

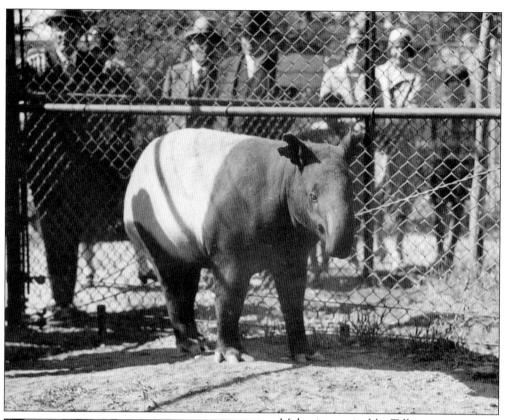

Malaysian tapirs like Tillie, seen
in this picture, are good swimmers
and are found in Southern Asia.
(Courtesy of the San Francisco Zoo.)

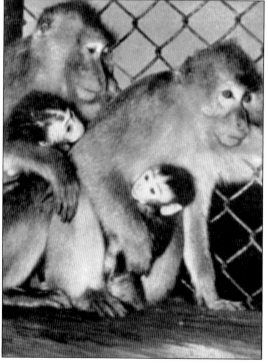

Java monkeys huddle closely
together for some monkey business
in this early postcard. (Courtesy
of the San Francisco Zoo.)

Zookeepers Fred Chatten, Norman Baker, and Louis Huddleston harness a male zebra in 1935. (Courtesy of the San Francisco Zoo.)

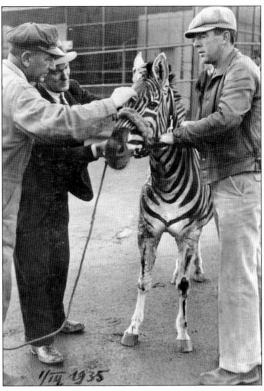

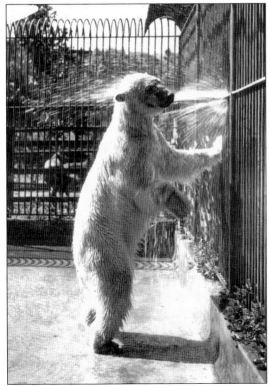

When keepers were not cleaning cages or preparing meals, they would hose off the animals on warm days, an idea first proposed by George Bistany. (Courtesy of the San Francisco Zoo.)

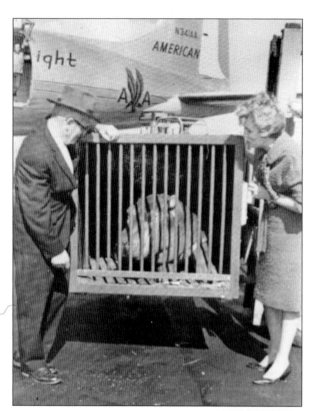

Puddles the hippopotamus arrives on an American Airlines flight. (Courtesy of the San Francisco Zoo.)

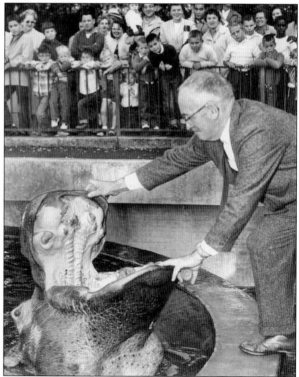

A 1958 zoo official opens Puddles's enormous mouth as eager children press up against the railing. (Courtesy of the San Francisco Zoo.)

Children in 1958 inch toward Puddles to get a better look. (Courtesy of the San Francisco Zoo.)

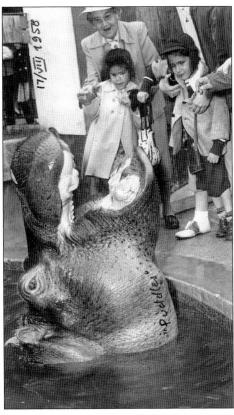

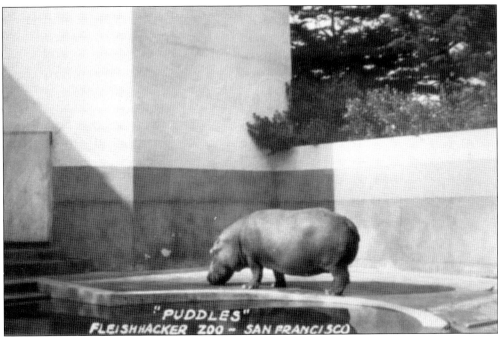

Puddles wanders around the exhibit in this early photograph. (Courtesy of the San Francisco Zoo.)

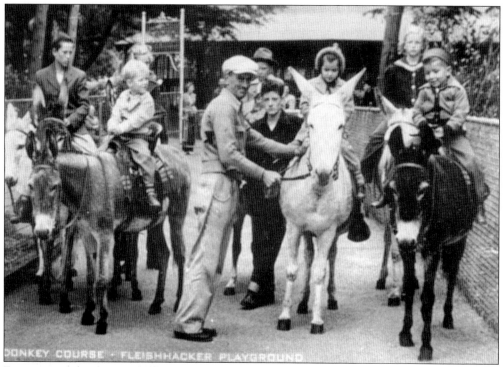

DONKEY COURSE · FLEISHHACKER PLAYGROUND

For just a couple of cents, children could parade around the zoo on the Donkey Course. (Courtesy of the San Francisco Zoo.)

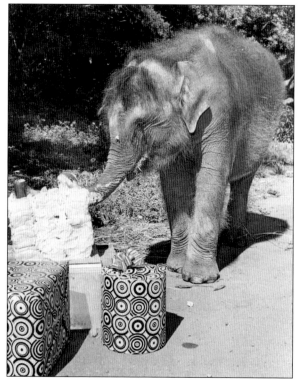

Jumbo, a baby elephant from Thailand, opens her birthday surprises. (Courtesy of the San Francisco Zoo.)

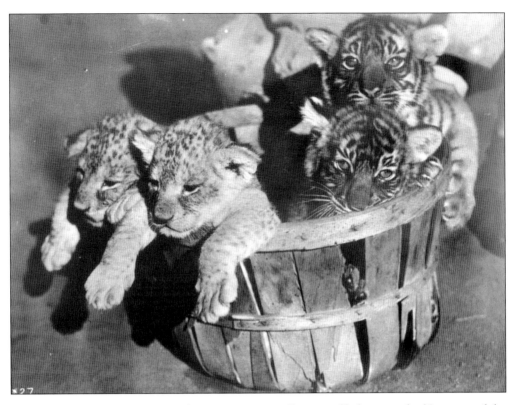

Lion and tiger cubs were among the zoo's growing collection of baby animals. (Courtesy of the San Francisco Zoo.)

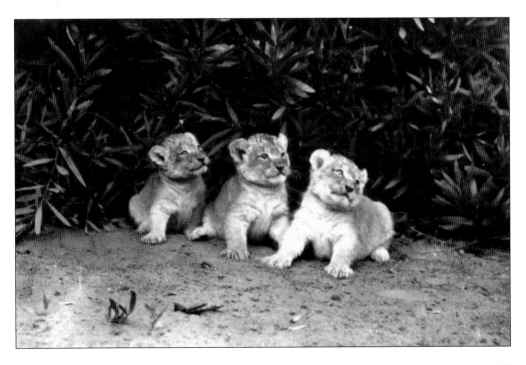

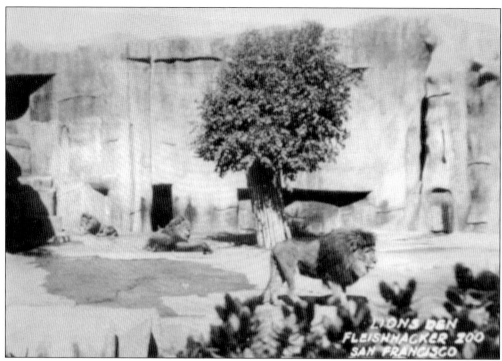

This postcard shows a male lion swaggering around his den before his midday meal. (Courtesy of the San Francisco Zoo.)

Former director of the Milwaukee Zoo Edmund Heller succeeded Bistany as Fleishhacker Zoo's second director in 1935. Heller also aided in the supervision of all WPA zoo construction. (Courtesy of the San Francisco Zoo.)

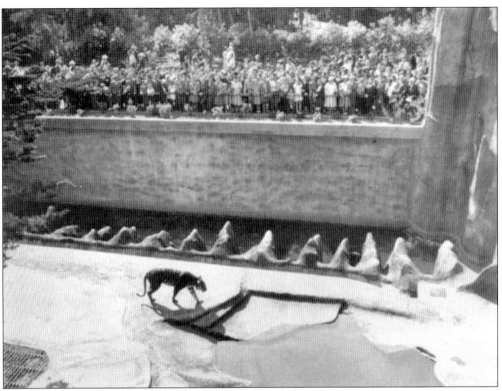

A tiger struts in front of a large crowd. (Courtesy of the San Francisco Zoo.)

The moats at the bottom of the tiger dens were filled with water to serve as an extra playing pool for the cats. (Courtesy of Harrison Edell.)

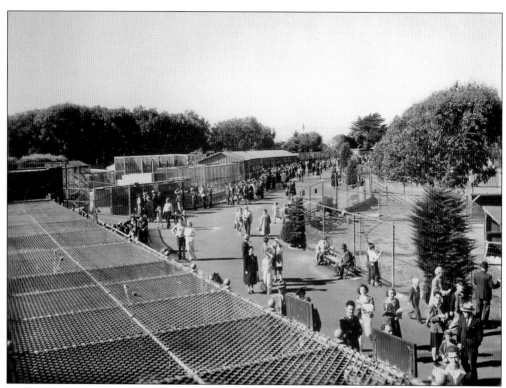

Visitors peer into cages teeming with different species of monkeys. (Courtesy of the San Francisco Zoo.)

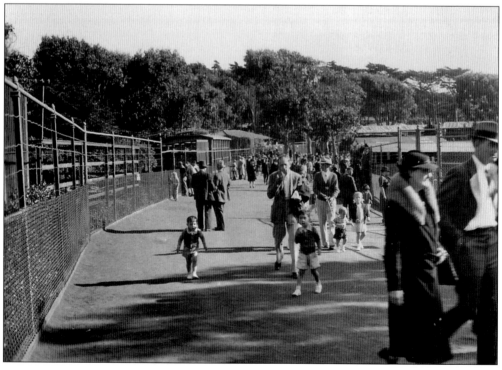

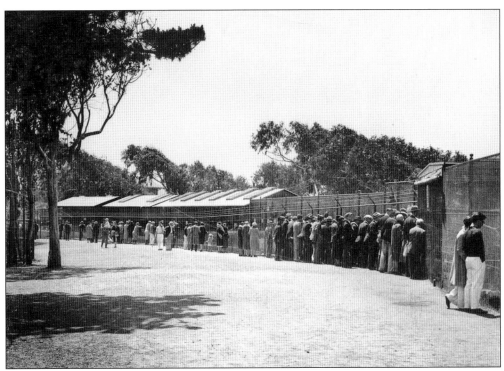

Crowds in 1934 gaze into cages that contain snow leopards, cheetahs, and other rare cat species. (Courtesy of the San Francisco Zoo.)

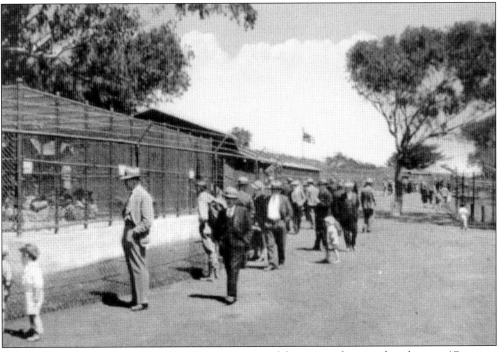

This stylized postcard from the 1950s illustrates some of the zoo's early animal enclosures. (Courtesy of the San Francisco Zoo.)

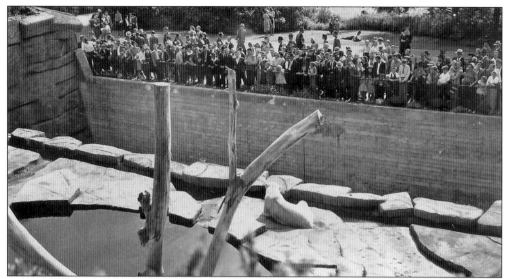

Spectators enjoy the site of a polar bear relaxing in its grotto. (Courtesy of the San Francisco Zoo.)

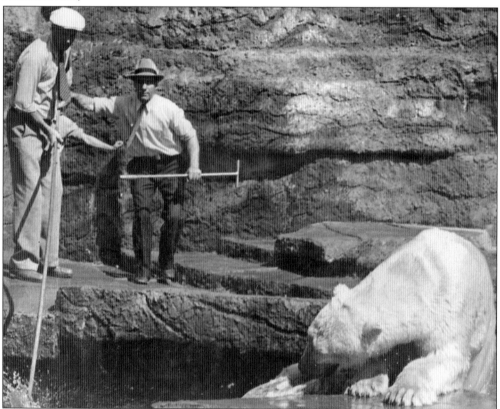

An article posted on October 7, 1940, read, "Attendants in the San Francisco Zoo, holding poles, attempt to shoo Big Billy away as he drags his dead mate, Min, to a pool in his pit and makes sure she is dead, by holding her beneath the water's surface." This is a practice polar bears employ in the wild. (Courtesy of the San Francisco Zoo.)

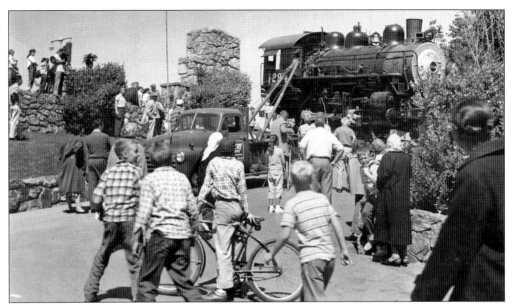

Made during 1924 in Lima, Ohio, Engine 1294 of the Southern Pacific Railroad had covered 1.5 million miles in its 33 years of operation. The train was rusting away in a Bayshore junkyard when papers petitioned to "give it to the kids." The Joseph D. Sheedy Drayage Company offered to move it to Fleishhacker Playfield for free, and four locals of the Teamsters Union contributed $1,000 to install safety features. In this photograph, the train is being brought into the zoo through the Sloat Boulevard entrance. (Courtesy of the San Francisco History Center, San Francisco Public Library.)

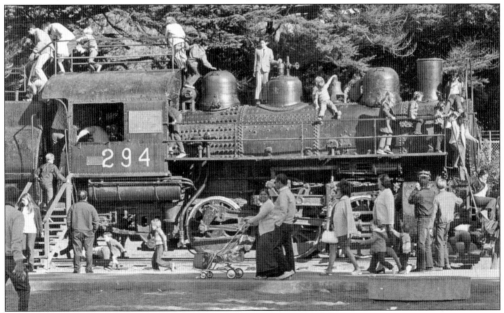

Spared the fate of the scrap yard, the 189,000-pound Engine 1294 was escorted on the 4-mile journey to the zoo by trucks, police motorcyclists with sirens, and a parade of over 100 people. The train was installed in the eastern section of Fleishhacker Playfield, and a dedication by Mayor George Christopher followed in the fall of 1957. Kids climbed atop the train and rang its shiny brass bell for over 30 years. (Courtesy of the San Francisco Zoo.)

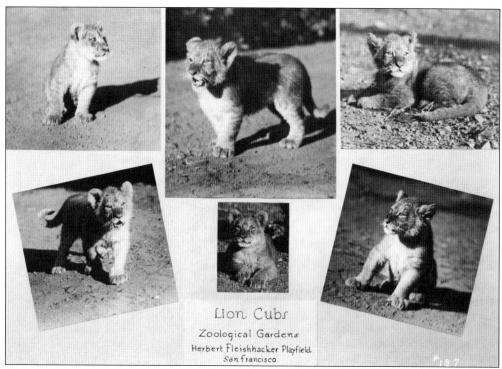

Lion Cubs

Zoological Gardens

Herbert Fleishhacker Playfield
San Francisco

This photogenic lion cub poses for an advertisement for Fleishhacker Zoo. (Courtesy of the San Francisco Zoo.)

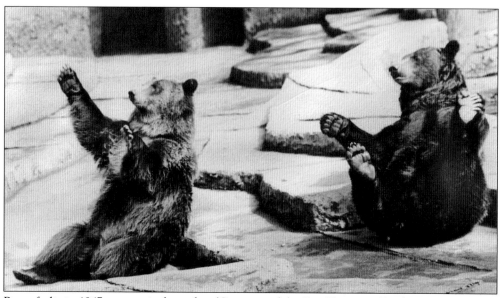

Bears frolic in 1947 on a typical zoo day. (Courtesy of the San Francisco Zoo.)

When Bay Area puppeteer Bruce Sedley grew tired of repeating his tales, he invented the original Talking Storybook and key. The zoo, one of the product's first supporters, purchased 40 Storybooks in 1959, renaming them Talking Storyboxes (pictured at right). Sedley's voice was the first to recite animal facts but was later replaced by celebrity voices and multilingual recordings. (Courtesy of the San Francisco Zoo.)

"All the animals at the zoo are jumping up and down for you!" was Sedley's catchy jingle that could be heard from a Talking Storybox with the turn of this key. (Courtesy of the San Francisco Zoo.)

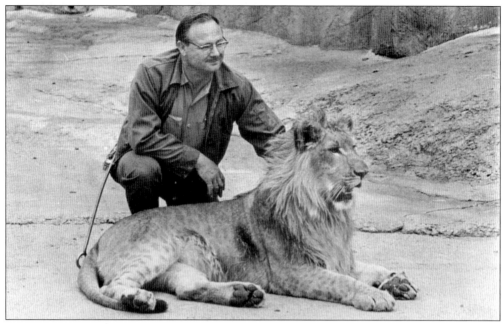

San Francisco native Jack Castor was in city hall paying his taxes when he noticed a want ad for an animal keeper. He got the job and served as the main lion and tiger keeper for 48 years, longer than any other city employee. He loved entertaining guests at the Lion House with his famous 2:00 p.m. daily feeding of the big cats. Jack passed away on October 23, 2008, at the age of 84, but his legacy and love for his cats will never be forgotten at the zoo. (Courtesy of the San Francisco Zoo.)

Castor's family recalls that he literally brought his work home with him in the form of a rejected lion cub, baby pig, or raccoon. Castor was fond of entertaining these guests in his living room with polkas from his accordion. One visiting raccoon actually thanked Castor for his generosity by turning on all the water faucets and flooding his house. (Courtesy of the San Francisco Zoo.)

Castor received over 500 stitches in his career but claimed they were "all just polite misunderstandings." He loved taking care of animals, and in return, they loved him. (Courtesy of the San Francisco Zoo.)

An early zoo philanthropist, Carroll Soo-Hoo first donated a zebra in 1958. Soon to follow were his donations of giraffes, orangutans, cheetahs, tigers, hyenas, and hippos. Soo-Hoo and his wife, Violet, became a familiar sight at the exhibits of their animal donations, particularly the gorillas Soo-Hoo cared for on weekends. In 1972, the *San Francisco Chronicle* recognized him as one of the Bay Area's Most Distinguished Men. Soo-Hoo served on the San Francisco Zoological Society's board of directors for over 10 years. (Courtesy of the San Francisco Zoo.)

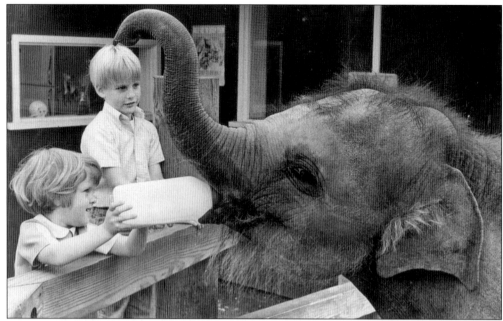

Children feed Taji, a baby Asian elephant in the Children's Zoo. Animals in this early form of the Children's Zoo could roam around freely and be handled and fed by visitors. Other baby animals included pygmy horses, goats, donkeys, a giant tortoise, bear and lion cubs, deer, llamas, chimpanzees, kangaroos, caracal sheep, gibbons, macaques, geese, turkeys, rabbits, piglets, and lemurs. Six months after the establishment of this "baby zoo," the San Francisco Zoological Society constructed its permanent Children's Zoo. (Courtesy of the San Francisco Zoo.)

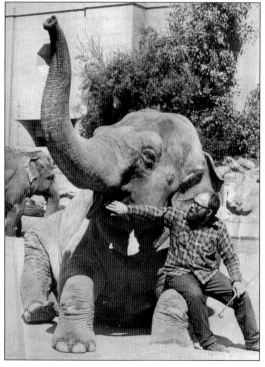

A 1970s elephant keeper rests alongside his charge. (Courtesy of the San Francisco Zoo.)

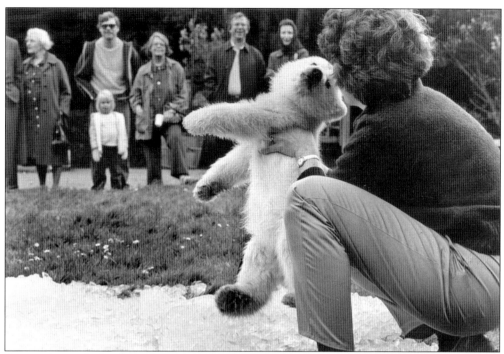

Zoo employee Gail informs an interested crowd in 1982 about her friend Pike, a polar bear cub. (Courtesy of the San Francisco Zoo.)

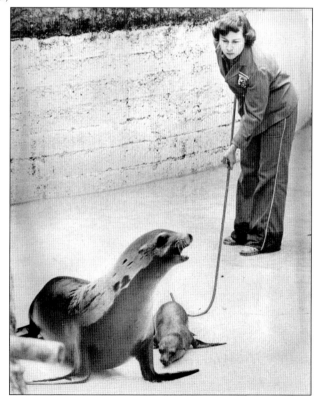

A keeper prepares to feed hungry seals their noontime meal. (Courtesy of the San Francisco Zoo.)

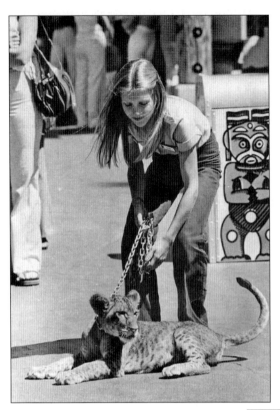

A keeper holds tight to a young lion. (Courtesy of the San Francisco Zoo.)

Keeper Martin "Big Bison" Diaz got his nickname from working with the zoo's bison population. He liked to name them after Shakespearian characters. In this photograph, Diaz is carrying a giant load of wheat bread from the commissary, where animal food is stored. (Courtesy of the San Francisco Zoo.)

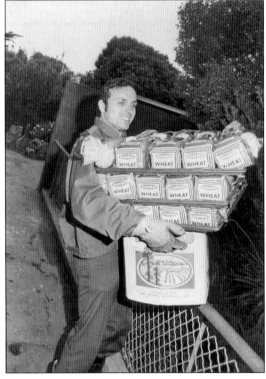

An infant gorilla clings to an attentive zoo docent. (Courtesy of the San Francisco Zoo.)

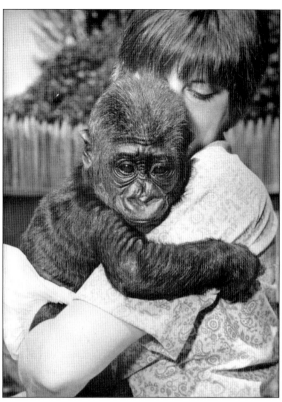

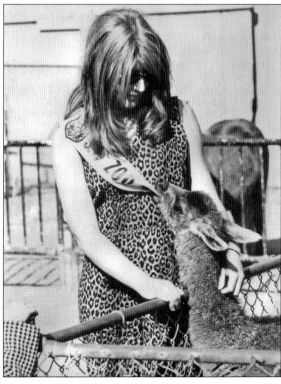

A baby llama chews on Miss Zoo's sash. (Courtesy of the San Francisco Zoo.)

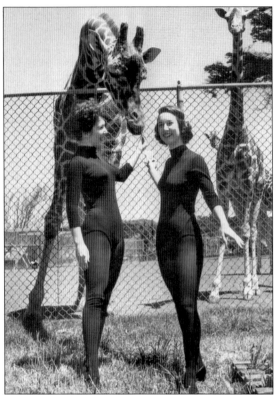

In the summer of 1963, Hotlips the giraffe reaches out his long neck to nuzzle the Lazalere twins, Mary (left) and Connie. The sisters, originally from Boston, were in the Bay Area to make appearances at a local club with the Ted Lewis Revue. (Courtesy of the San Francisco Zoo.)

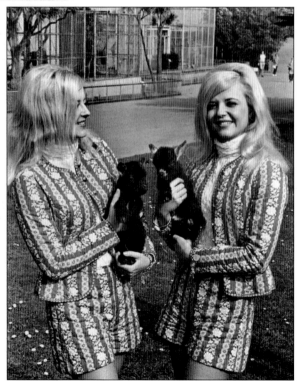

Becki and Barbi Sellers, pictured with two young goats, won the title of Miss Twins 1972. (Courtesy of the San Francisco Zoo.)

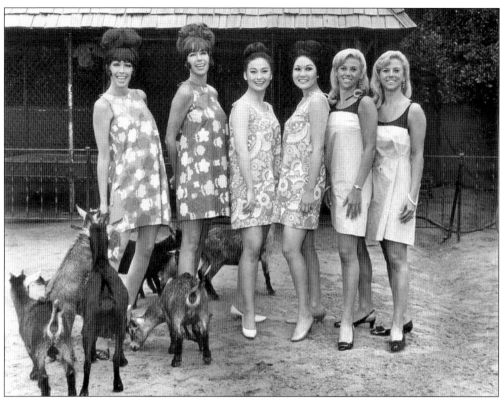

Three sets of twins visit the petting zoo in the 1960s. (Courtesy of the San Francisco Zoo.)

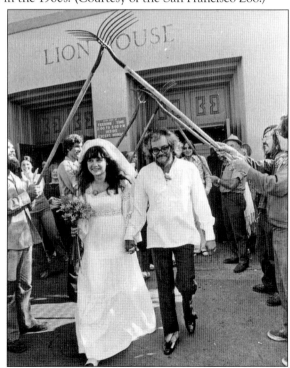

Ape keeper John Alcarez marries Silvia Stewart inside the Lion House. His fellow keepers celebrate the newlyweds after the "roaring" ceremony. (Courtesy of the San Francisco Zoo.)

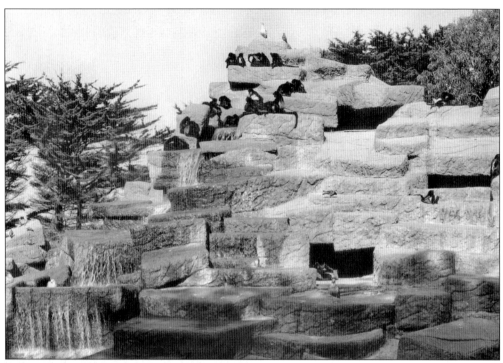

Built as part of the WPA construction, the world-famous Monkey Island was home to a troop of over 25 spider monkeys. (Courtesy of the San Francisco Zoo.)

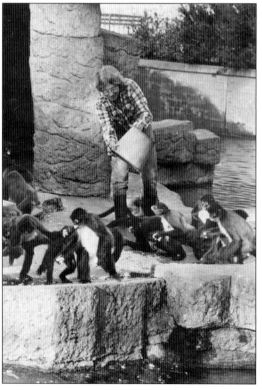

A keeper doles out the daily meal of fruits and nuts to the spider monkeys. (Courtesy of the San Francisco Zoo.)

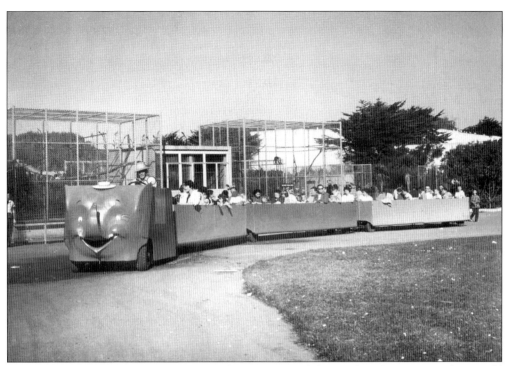

The elephant train lecture and tour guided visitors around the zoo for 25 minutes. Tickets could be purchased at a stand across from the camels. (Courtesy of the San Francisco Zoo.)

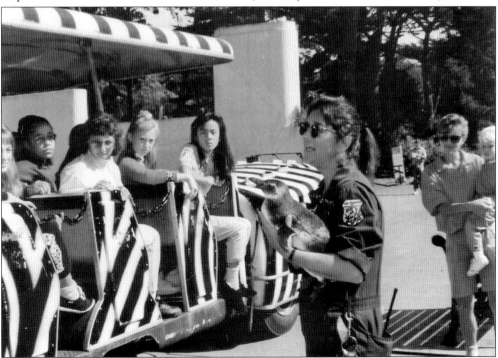

Penguin keeper Carol Cone converses with young Nature Trail volunteers enjoying a ride on a Zebra Zephyr Train tour. (Courtesy of the San Francisco Zoo.)

An early zoo map and ticket are shown. Notice how admission is free on the ticket. (Courtesy of the San Francisco Zoo.)

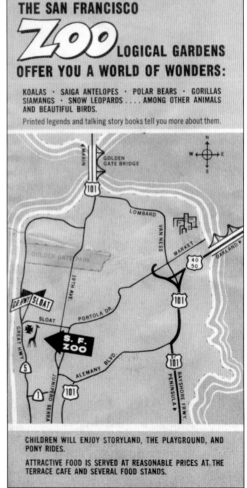

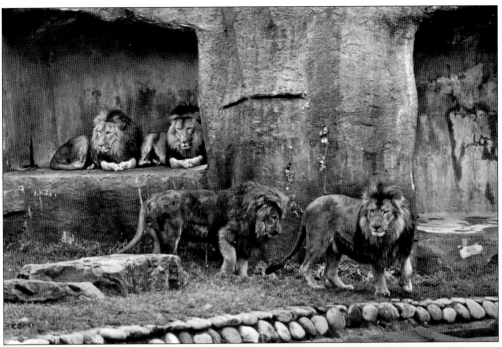

African male lions, part of the zoo's enormous big cat collection, relax in their grotto. (Courtesy of the San Francisco Zoo.)

Native to the open savannahs of eastern Africa, these hyenas share lunch under the supervision of keeper Henry Poggi (not pictured) in 1964. (Courtesy of the San Francisco Zoo.)

Bwana, the patriarch of the zoo's gorilla family, was one of the world's oldest captive gorillas. (Courtesy of the San Francisco Zoo.)

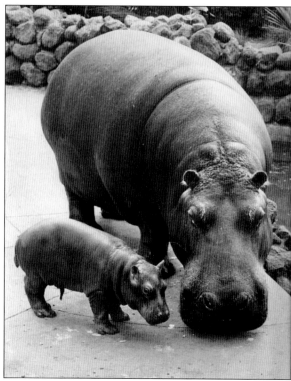

A mother hippopotamus and her calf dry off from their swim. (Courtesy of the San Francisco Zoo.)

Three

THE SAN FRANCISCO ZOOLOGICAL SOCIETY

On February 27, 1941, the zoo officially became known as the San Francisco Zoological Gardens at the request of Herbert Fleishhacker. The San Francisco Zoological Society, a nonprofit membership organization, was formed in 1954. Though the city owns the property and animals, the San Francisco Zoological Society manages all daily operations. (Courtesy of the San Francisco Zoo.)

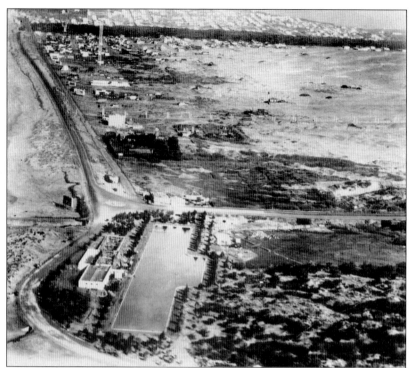

Fleishhacker Pool and the pool house are seen in this mid-1920s photograph. The dark horizontal band at the top is Golden Gate Park, and the Richmond District lies to the north. Construction of the outer Sunset District had not begun at this point. (Courtesy of the San Francisco Zoo.)

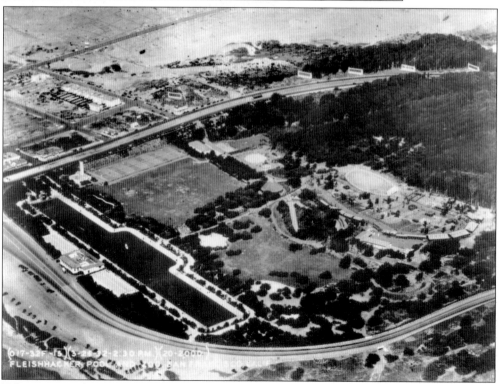

Taken in 1936, this aerial view shows the pool, as well as parts of the early central zoo. Sand dunes still make up the Sunset District. (Courtesy of the San Francisco Zoo.)

The pool and the main zoo are seen, as well as the complete development of the Sunset District. (Courtesy of the San Francisco Zoo.)

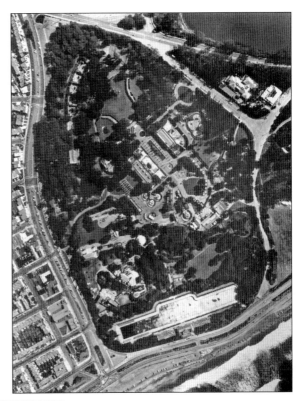

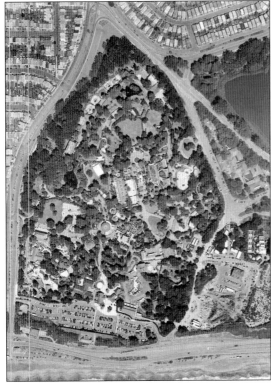

In 2004, the pool is no longer there, but its distinct rectangular shape can still be seen at the site of the zoo's parking lot. (Courtesy of the San Francisco Zoo.)

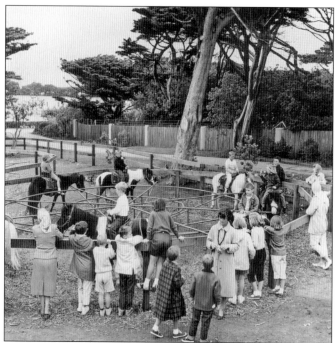

Shetland ponies were tied to a giant wheel, causing them to move in slow circular routes, unlike the frisky ponies at Golden Gate Park's pony ride. Visitors could round the circle for a mere 20¢ per ride. (Courtesy of the San Francisco Zoo.)

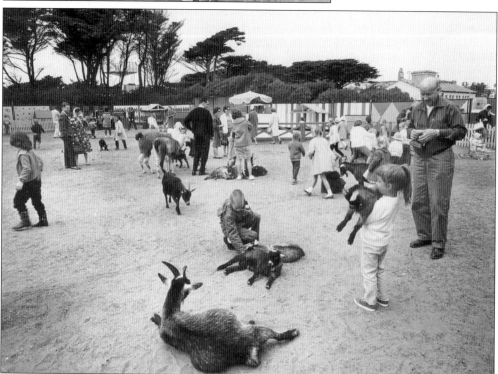

The Family Farm Petting Zoo, located within the Children's Zoo, provides young visitors with an opportunity to meet goats, sheep, donkeys, and chickens. In 1959, Sam Miller of Laytonville donated the first livestock. The earliest Petting Zoo is seen here in this 1960s photograph. (Courtesy of the San Francisco Zoo.)

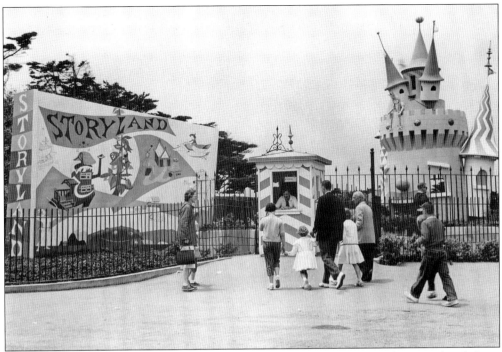

In the summer of 1959, the zoo opened its 3-acre Storyland, an outdoor playground with large scenes from nursery rhymes and fairy tales designed by local artist Don Clever, designer of the popular elephant train ride. (Courtesy of the San Francisco History Center, San Francisco Public Library.)

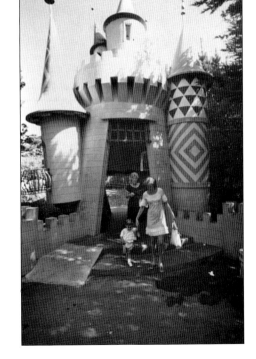

While admission to the main zoo was free, Storyland cost children 10¢ and adults 15¢. The hours of operation were from 10:00 a.m. to 5:30 p.m. Children entered through Rapunzel's Castle, but adults had to use the pedestrian walkway because the castle was only the correct height for small children. (Courtesy of the San Francisco Zoo.)

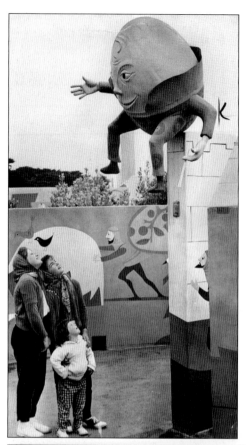

The action sets included a See Saw Marjorie Daw teeter-totter, Jack and Jill slide, Ring Around the Rosie merry-go-round, Witches' House and School House playhouses, and a Humpty Dumpty maze. (Courtesy of the San Francisco History Center, San Francisco Public Library.)

Food could be purchased at the Mad Hatter's Munch Bar, and drinking fountains featured Babar the elephant and Town Mouse and Country Mouse. Audio greetings welcomed visitors to scenes from Ole King Cole, Rapunzel's Castle, Goldilocks and the Three Bears, and the Old Woman Who Lived in a Shoe circular slide, pictured below. (Courtesy of the San Francisco Zoo.)

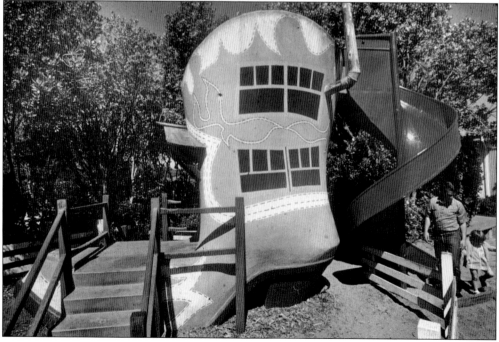

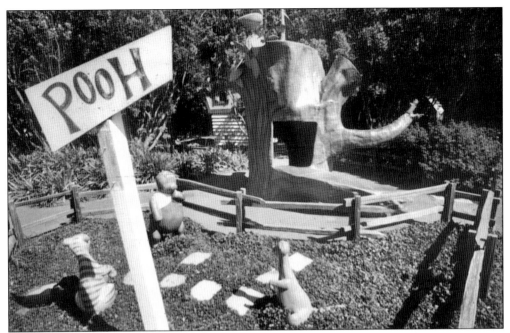

This scene from Winnie the Pooh added to the magic of Storyland. In February 1964, the San Francisco Recreation and Park Department turned over all operation of Storyland to the San Francisco Zoological Society, and it became a permanent part of the Children's Zoo. (Courtesy of the San Francisco Zoo.)

Mother Goose, Old Mother Hubbard, Hansel and Gretel, Little Red Riding Hood, and Alice in Wonderland were among Storyland's 26 fairy tale nursery rhyme characters. Pictured above is "Jack Sprat [who] could eat no fat [and] his wife [who] could eat no lean." (Courtesy of the San Francisco Zoo.)

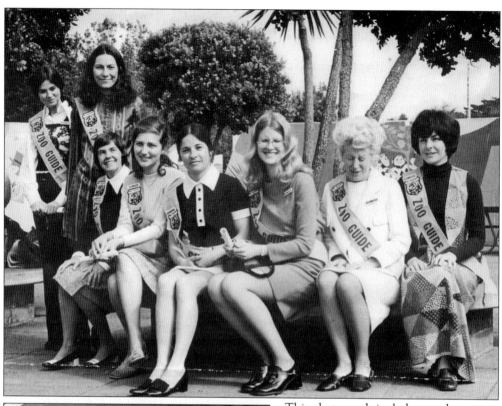

This photograph includes zoo docents Virginia Boschen, Susan Sherman, JoAnn Harley, Anna Shaff, Milly Gillis, Allene Borromeo, Candy Mantos, and other unnamed volunteers. The adult docent program was created in the early 1970s and continues to serve the zoo today. Volunteers emphasize conservation by leading educational tours around the zoo. (Courtesy of the San Francisco Zoo.)

Docents in 1971 pose for a class photograph in front of the Shoong Auditorium. (Courtesy of the San Francisco Zoo.)

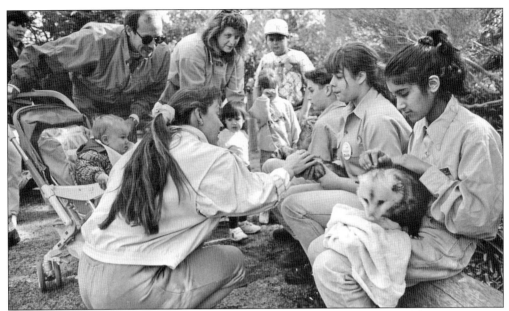

In 1976, zoo employee Lora LaMarca created the Nature Trail summer program. She hoped to create a place of discovery where the public could walk through and meet animals up close. Young volunteers between the ages of 12 and 15 are trained in basic animal handling techniques as well as public speaking skills. LaMarca's program has proven to be a place where youth can be advocates for animals and conservation. (Courtesy of the San Francisco Zoo.)

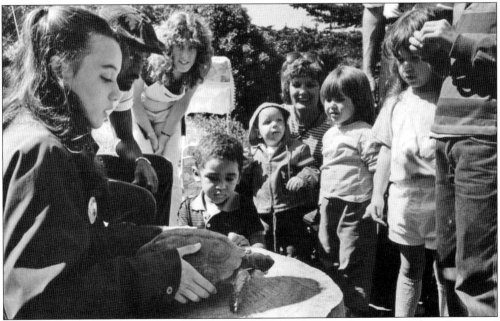

The Nature Trail today has expanded to over 250 active volunteers. Starting with a small group of teens in 1976, the program has produced over 18,000 graduates. An estimated 50,000 people stroll down the Nature Trail every summer. This innovative program has been featured in magazines and television programs and has inspired other zoos across the country to create similar programs. (Courtesy of the San Francisco Zoo.)

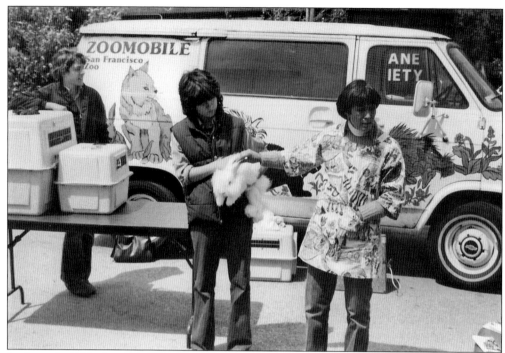

In the early 1970s, Lora LaMarca decided it was time for the zoo to go mobile. The first Zoomobile was LaMarca's Mustang. She loaded a lion cub, African hedgehog, and pygmy goat into the back seat. A former teacher, LaMarca traveled with the small animals to schools and children's hospitals to aid in art, science, and language. Though no longer a Mustang, the Zoomobile van is still popular among local schools and inspires conservation. Lora LaMarca is now the director of marketing and public relations at the zoo. (Courtesy of the San Francisco Zoo.)

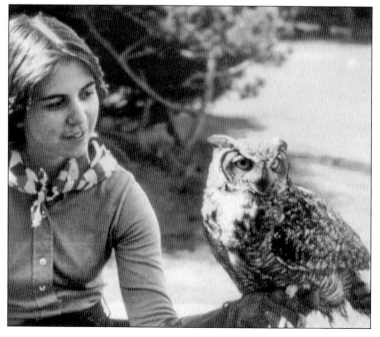

Volunteer Jeanne Brenner poses with one of the Animal Resource Center's (ARC) oldest animals, a great horned owl named King Richard, born in 1962. Taken from her nest when she was young, King Richard was malnourished and was unable to grow properly. Males are smaller than females, and King Richard was presumed male until she laid her first egg one day on the Zoomobile. (Courtesy of the San Francisco Zoo.)

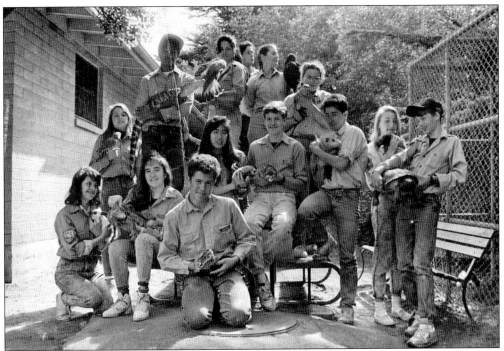

The small animals that are used on the Nature Trail and the Zoomobile live in the ARC. Teen junior zoologists, who are former Nature Trailers and over 16 years of age, care for ARC's 100-plus animals during the school year. (Courtesy of the San Francisco Zoo.)

A volunteer places a bird of prey on a perch behind the ARC. Originally located near the Great Highway entrance, the ARC was moved in the late 1990s to its current location in the Children's Zoo behind Hawk Hill. (Courtesy of the San Francisco Zoo.)

The indoor Insect Zoo started as a temporary exhibit in 1979 but proved so popular that it immediately became a permanent part of the Children's Zoo. (Courtesy of Stephen Girlich)

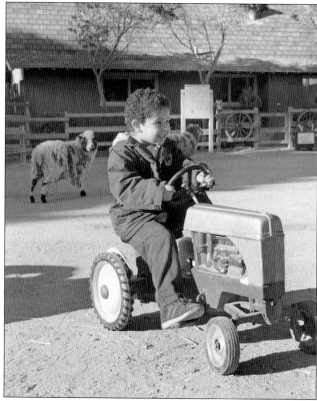

The Children's Zoo, or Family Farm, currently includes two barns and allows guests to feed donkeys, sheep, and goats, as well as play with the roaming chickens and roosters. (Courtesy of the San Francisco Zoo.)

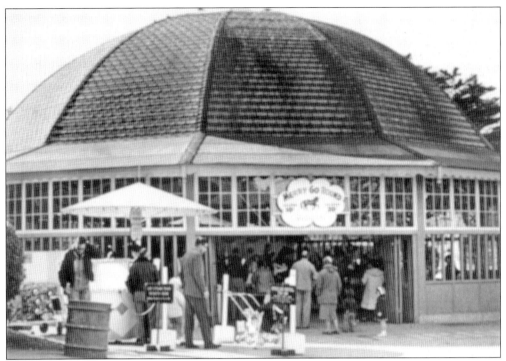

Handcrafted by William H. Dentzel in 1921, the zoo's carousel was later renamed to honor Bay Area philanthropist Eugene Friend. The carousel arrived at the zoo in 1925 from the Pacific City Amusement Park in Burlingame and served as one of the zoo's first major attractions. The carousel is one of only seven Dentzel Carousels left in the United States. (Courtesy of the San Francisco Zoo.)

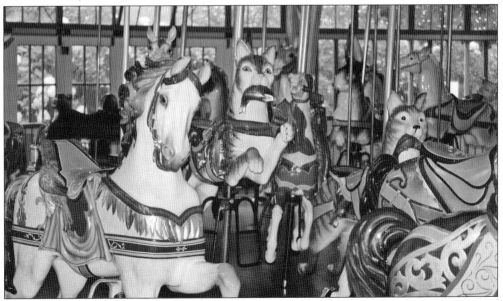

Located today in the Koret Carousel Plaza, the carousel features two chariots and 50 hand-carved wooden animals embellished with jewels. These elaborate creatures include horses, giraffes, ostriches, tigers, lions, pigs, rabbits, cats, and reindeer. (Courtesy of Stephen Girlich.)

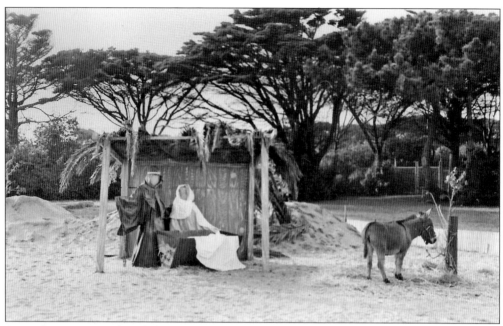

A wooden manger and a real donkey complete this Christmas scene in December 1965. (Courtesy of the San Francisco Zoo.)

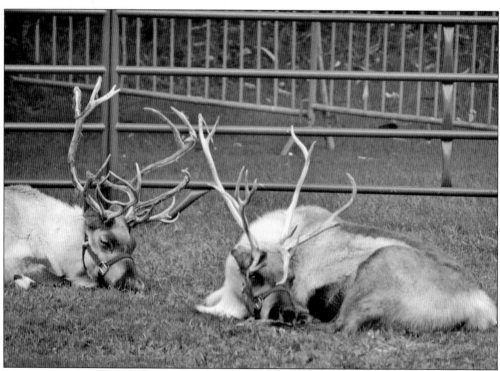

The zoo now celebrates the holiday season with an annual ice skating rink and hosts four reindeer named Holly, Peppermint, Velvet, and Belle in its Reindeer Romp exhibit. (Courtesy of Stephen Girlich.)

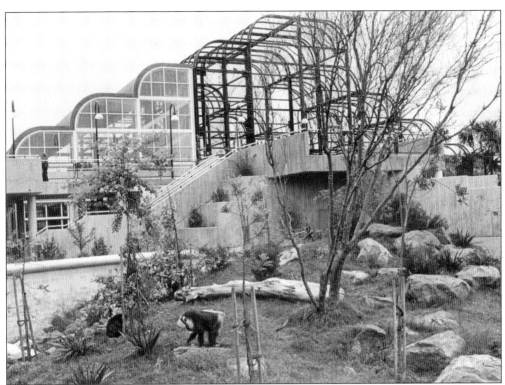

The Thelma and Henry Doelger Primate Discovery Center is home to some of the most endangered primate species in the world, including Francois' langurs, black howler monkeys, siamangs, emperor tamarins, pied tamarins, and lion-tailed macaques. The double-leveled exhibit provides primates with plenty of space and high climbing structures, as well as luxurious outdoor yards that resemble natural settings. (Courtesy of the San Francisco Zoo.)

Holding Jenny, a four-month-old Celebes black ape, Mayor Dianne Feinstein appropriated $100,000 of city funding toward the zoo's $6.5 million Primate Discovery Center. The article that accompanied this newspaper photograph was published on January 5, 1984, and illustrated San Francisco's role in maintaining genetic diversity in animals. (Courtesy of the San Francisco Zoo.)

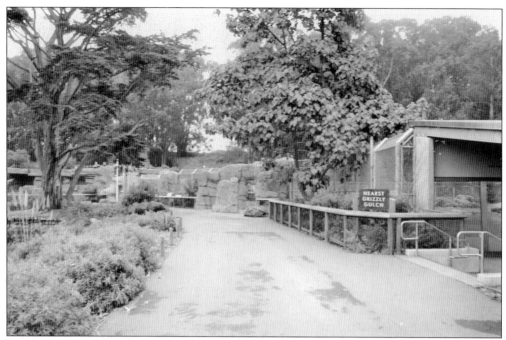

Built in 2004, the 1-acre Hearst Grizzly Gulch, located between the zoo's original bear dens and the rhinoceros enclosure, includes a meadow, a 200,000-gallon pool, and a mountain stream waterfall. Grizzly Gulch proves to be one of the largest naturalistic environments dedicated completely to grizzly bears in any zoo. (Courtesy of Stephen Girlich.)

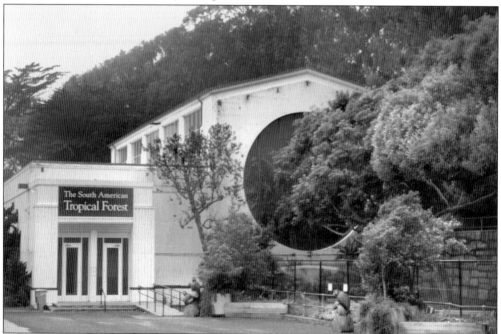

The Aviary was converted into a tropical walk-through aviary in 1970. The back cages, once located on the other side of the circle pass, were torn down for an outdoor exhibit, and the circle was sealed with glass panels. (Courtesy of Stephen Girlich.)

The Terrace Café, with outdoor seating overlooking the bear grottos, serves daily meals including salads, sandwiches, pizza, gourmet desserts, and the popular pink popcorn. Proceeds from all purchases support the animals and programs at the zoo. (Courtesy of the San Francisco Zoo.)

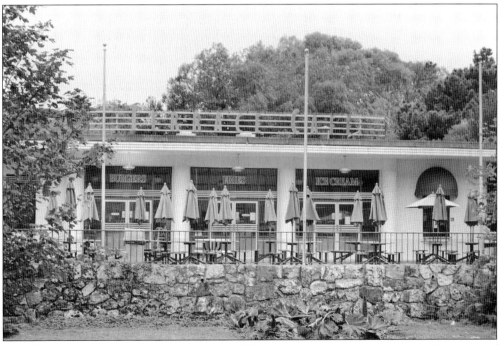

The Terrace Café was renovated in the 1990s to preserve its retro design. (Courtesy of Stephen Girlich.)

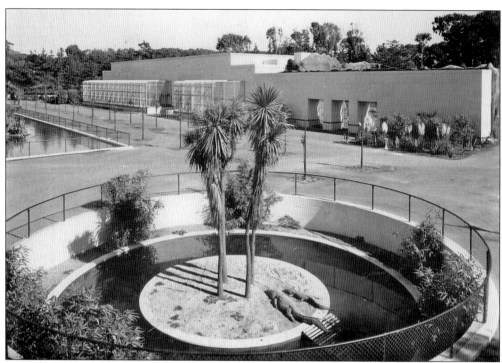

The Alligator Pit, one of the zoo's original exhibits, was torn down after over half a century of service to make room for Otter River. (Courtesy of the San Francisco Zoo.)

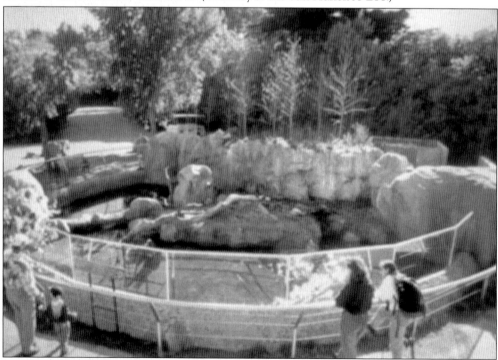

The Otter River exhibit was constructed in 1994 to house North American river otters. (Courtesy of the San Francisco Zoo.)

After almost 40 years of operation, the beloved Storyland structures were removed and replaced by animal exhibits. Rapunzel's Castle was the last to be demolished in 1996, and a new Children's Zoo entranceway was constructed in its place. The Nature Trail path, trout stream, wetlands interpretive station, and a large bronze statue of geese now also reside where Storyland once stood. (Courtesy of the San Francisco Zoo.)

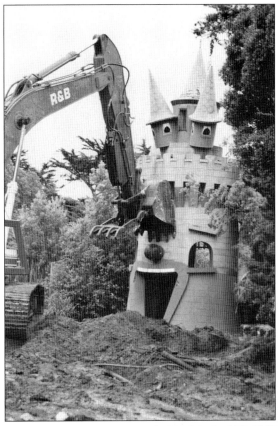

Monkey Island was demolished in 1995. (Courtesy of the San Francisco Zoo.)

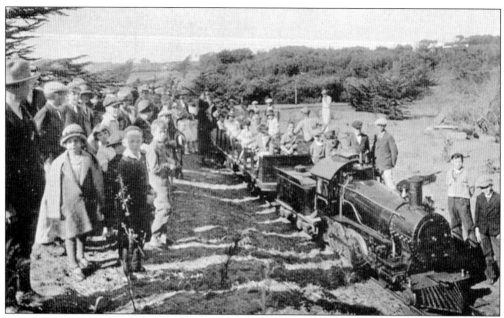

Around the beginning of the 20th century, the Cagney Brothers' Miniature Railroad Company manufactured seven 22-inch gauge Class E miniature steam locomotives. These trains were not created for work or long distance transportation but rather as a source of entertainment and amusement. (Courtesy of the San Francisco Zoo.)

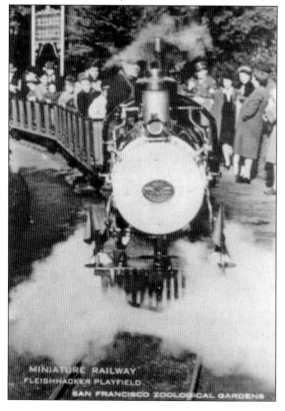

Records indicate that this train served at Santa Cruz Beach from 1907 to 1915. The train had been reduced to scraps and resided in a junkyard between Third and Brannan Streets after it had almost been destroyed in a warehouse fire. In the 1920s, a Ford car dealer named Joseph Cornelius Hayes purchased the train for three cases of gin and a used Oldsmobile. (Courtesy of the San Francisco Zoo.)

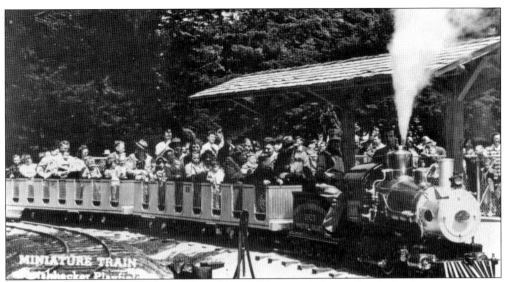

The newly restored train was to be relocated to San Francisco's Ocean Beach, but fire commissioners would not allocate a permit because the coal-burning locomotive proved to be a fire hazard. Rather than impounding the train, officials hid it for two years in an old abandoned stable in Burlingame. It was there that Herbert Fleishhacker purchased the train in 1925 and installed it at the new Herbert Fleishhacker Playfield. (Courtesy of the San Francisco Zoo.)

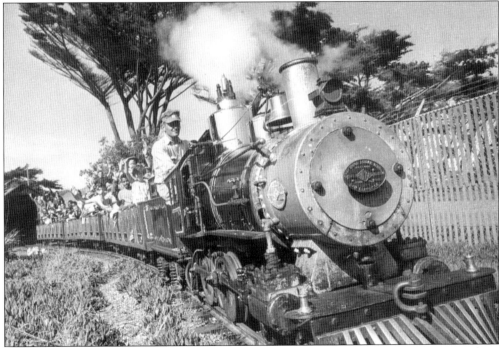

The train was renamed the California Zephyr in 1965 when the Western Pacific Railroad sponsored a restoration of the train and tracks. In 1978, it was retired to make way for Gorilla World. The train returned in the late 1990s and continues to "round a bend" every day. The train, affectionately known today as Little Puffer, is pushing 100 years of age and is one of only three remaining 22-inch gauge engines left in the world. (Courtesy of the San Francisco Zoo.)

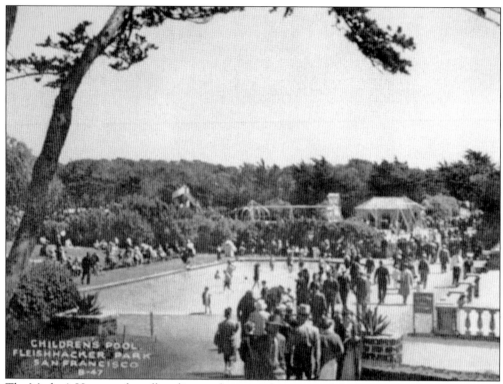

The Mother's House and small wading pool remained in use until the late 1960s when the matrons who had assisted the mothers retired. (Courtesy of the San Francisco Zoo.)

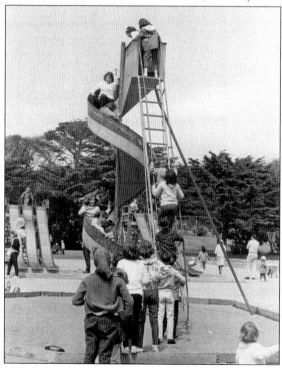

The spiral slide was one of several popular playground structures to rise around the outskirts of the Mother's House. (Courtesy of the San Francisco Zoo.)

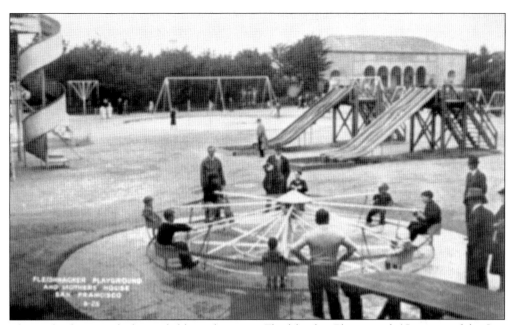

This early photograph shows children playing on Fleishhacker Playground. (Courtesy of the San Francisco Zoo.)

Today lawn (seen on the right) has replaced the spot where the Mother's House wading pool once stood. (Courtesy of Stephen Girlich.)

Trees block the exterior of the Lion House, and the cages on the outside are no longer in use. (Courtesy of Stephen Girlich.)

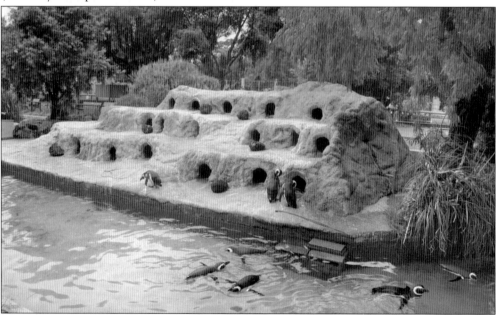

The 200-foot-long pool located in between the Lion House and elephant exhibit was built during WPA construction. Originally a reflecting pool, it later hosted squirrel monkeys, seals, and Humboldt penguins. A renovation in 1984 landscaped the central island with 35 tons of black volcanic rock similar to that found in the penguin's natural habitat. Magellanic penguins, pictured above, currently reside on the zoo's Penguin Island and prove to be quite a spectacle during their daily 2:30 p.m. public feedings. (Courtesy of Stephen Girlich.)

Fleishhacker Pool was losing popularity as warm, indoor, and freshwater pools were built throughout the city. Following a destructive storm, the pool closed in 1971 after years of deterioration and the inability to meet modern health standards. It lay dormant for several years until it was filled with sand and gravel to serve as an access road for maintenance trucks. (Courtesy of the San Francisco Zoo.)

In the summer of 2002, the pool that once held record-breaking Olympic swim trials became the site of a visitor parking lot. (Courtesy of Stephen Girlich.)

The zoo's original Sloat Boulevard entrance and the Mother's Building gift shop permanently closed in 2002. (Courtesy of the San Francisco Zoo.)

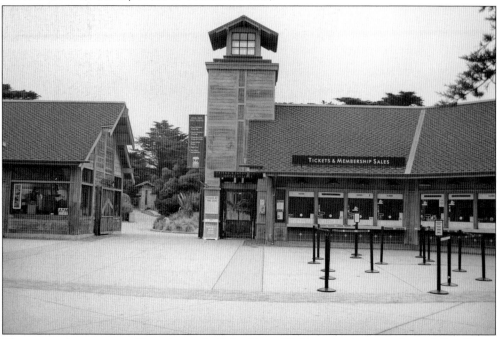

The new main entrance village, located off the Great Highway, leads guests through Zoo Street and into the African Savanna. The Wildlife Connection gift shop was erected to the left of the ticket sale windows. (Courtesy of Stephen Girlich.)

This photograph shows the giraffe barn in the 1950s. (Courtesy of the San Francisco Zoo.)

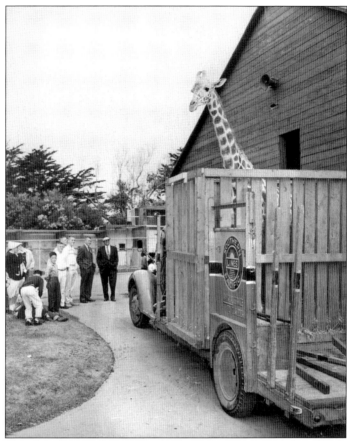

The new giraffe barn is now part of the 3-acre African Savanna, which opened in 2004. The giraffes share their exhibit with zebras, kudu, and oryx. (Courtesy of Stephen Girlich.)

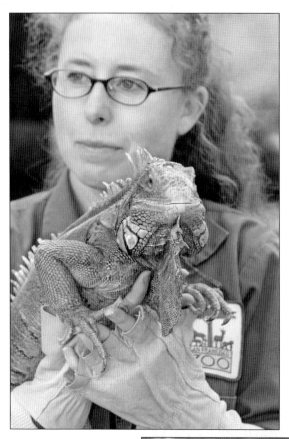

Jessie Bushell, seen here with an iguana named Izzy, began as a volunteer on the Nature Trail when she was 12 years old. She was hired to work at the ARC as an education specialist over 14 years ago and currently holds the position of ARC supervisor. An active conservationist, Jessie channels her enthusiasm for wildlife by overseeing all teen and adult volunteers. Among Jessie's favorite animals in the ARC is Inti, a bobcat who resides just a few feet away from her office. (Courtesy of the San Francisco Zoo.)

John Flynn, an adult volunteer at the Avian Conservation Center and ARC for over 17 years, enjoys working with birds of prey. In this photograph, John holds tightly to Sequoia, an 11.5-pound bald eagle that enjoys to fly freely under his supervision. John and Sequoia exemplify the zoo's emphasis on conservation programs and the importance of building relationships between humans and disappearing wildlife. (Courtesy of the San Francisco Zoo.)

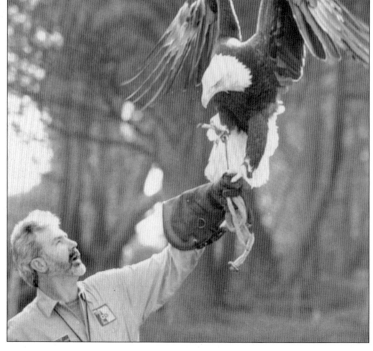

ABOUT THE AUTHOR

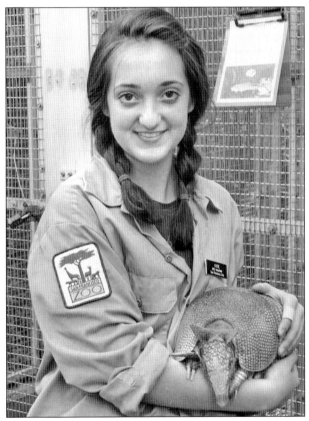

I have lived a heartbeat away from the zoo my entire life. In fact, I can hear the lions, peacocks, and Little Puffer from my bedroom window. In researching this book, I discovered that the zoo has been a part of my family since before I was born. My grandmother Evelyn recalled fond memories of her uncle, Joe Cirimelli, who was an entertainer and high-dive performer at Fleishhacker Pool in the late 1930s. I became a volunteer on the Nature Trail in the summer of 2005 after being persuaded by my best friend and neighbor, Lisa Hipp, to attend an orientation. After having spent two years on the Nature Trail, I am currently a junior zoologist at the ARC, where I spend my weekends and summers caring for the animals. The zoo and its inhabitants have shaped the person I am today and have changed my life forever. (Courtesy of Jennifer Rauch.)

ACROSS AMERICA, PEOPLE ARE DISCOVERING SOMETHING WONDERFUL. *THEIR HERITAGE.*

Arcadia Publishing is the leading local history publisher in the United States. With more than 5,000 titles in print and hundreds of new titles released every year, Arcadia has extensive specialized experience chronicling the history of communities and celebrating America's hidden stories, bringing to life the people, places, and events from the past. To discover the history of other communities across the nation, please visit:

www.arcadiapublishing.com

Customized search tools allow you to find regional history books about the town where you grew up, the cities where your friends and family live, the town where your parents met, or even that retirement spot you've been dreaming about.